MARITIME
ANNAPOLIS

MARITIME
ANNAPOLIS

A HISTORY *of* WATERMEN,
SAILS & MIDSHIPMEN

ROSEMARY WILLIAMS

THE
History
PRESS

Published by The History Press
Charleston, SC 29403
www.historypress.net

Copyright © 2009 by Rosemary F. Williams
All rights reserved

Front cover: Painting by Rosemary Freitas Williams. Cover photo by Charles E. Emery.
Back cover: Photos courtesy of the United States Naval Academy Archives and A. Aubrey
Bodine, © Jennifer B. Bodine, www.aaubreybodine.com.

First published 2009
Second printing 2010
Third printing 2011

Manufactured in the United States

ISBN 978.1.59629.659.6

Library of Congress Cataloging-in-Publication Data

Williams, Rosemary F.
Maritime Annapolis : a history of watermen, sails and midshipmen / Rosemary F.
Williams.
p. cm.
Includes bibliographical references.
ISBN 978-1-59629-659-6
1. Annapolis (Md.)--History. 2. Boats and boating--Maryland--Annapolis--History.
3. Boats and boating--Chesapeake Bay (Md. and Va.)--History. 4. United States Naval
Academy--History. I. Title.
F189.A64W55 2009
975.2'56--dc22
2009015771

For John, through whom all things are possible.

CONTENTS

CONTENTS

PREFACE

To clarify, I am a journalist, not a historian.

As a field journalist and executive producer, I have been fortunate enough to cover some of the bigger events in modern history—the first democratic election in South Africa, a presidential summit in Moscow, the impeachment of a sitting president, five presidential campaigns and the attacks of September 11, 2001. I have also covered a multitude of relatively small events, news that made only local headlines—a fatal fire at a North Carolina food-processing plant, many stories highlighting the goodwill of people during the holidays and some stories covering natural disasters that reinforce the fragility of life. The people and events that stay with me, the images that come to my mind from time to time, are the so-called *everyday people* who have done extraordinary things.

As a journalist and resident of Annapolis, the maritime history of this town has always fascinated me. Through trips to the Maryland Archives and conversations with longtime residents, I gathered glimpses of life during the heyday of harvesting oysters, Annapolis's Golden Age of Sail and the heady days of boat design and construction during the famed Trumpy Yacht era. In 2008, I had the great good fortune of being asked to install a historic timeline at the National Historic Registry property located at 222 Severn Avenue in Eastport, owned by Cardie Templeton Hannon and the Templeton family. This is where Chance Boatyard, Annapolis Yacht Yard and John Trumpy & Sons ran their historic boatyards in succession over a seventy-year period. For several months, I gathered old photos, researched the stories and talked to people who have firsthand accounts of the magnificent work done at that storied property on the Eastport peninsula of Annapolis. Many of the main players had humble beginnings. They learned their craft from their fathers, who in turn had fathers who were the first to make their livings by working on the bay. They were *everyday people* doing extraordinary things, and I was hooked.

PREFACE

This book is about the facts of maritime Annapolis as we know them today, facts culled from numerous books, articles, documents and personal interviews. I did not interpret or analyze in this book—I leave that to the impressive list of Annapolis historians who have dedicated their lives to recording the city's history. While it is not an exhaustive, unabridged study of every facet of our entire maritime history, I do hope that the stories and events I have assembled will enlighten, entertain and leave you with an appreciation of the magnificent people on the water who came before us and the events that contributed to the colorful and tightly woven fabric that is our wonderful city today.

Of the many books available on the different facets of Annapolis's maritime history, several were extraordinarily helpful in the research of this book and are worth reading for anyone interested in learning more about maritime Annapolis. These include *Tobacco Coast: A Maritime History of Chesapeake Bay in the Colonial Era* by Arthur Pierce Middleton; *Cruising Mostly the Chesapeake* by the Barrie brothers, George and Robert; *Chesapeake Sails: A History of Yachting on the Bay* by Richard "Jud" Henderson; *Oyster Wars* by John R. Wennersten; and *The United States Naval Academy* by Jack Sweetman.

I extend a heartfelt thank-you to the many people who helped with this book, including (alphabetically): Claire Ahern; Lieutenant Commander Claude Berube, USNR; Annapolis's chief preservationist, Patricia Blick; Jennifer Bodine, daughter of A. Aubrey Bodine and caretaker of his extraordinary photographs; writer, journalist and editor Janice F. Booth; Katherine Burke of the dazzling Annapolis Collection Gallery on West Street; Glenn Campbell of the Historic Foundation of Annapolis; James Cheevers, senior curator of USNA Museum; Heather Ersts, curator of the Annapolis Maritime Museum; Cardie Hannon, who provided the inspiration for this book; Fred Hecklinger; Melvin Howard, a third-generation Eastporter; Vincent Leggett; Ray and Jean Langston of Highland Beach; Pete Lesher, curator of the Chesapeake Bay Maritime Museum; Jane McWilliams; Captain Richards Miller, USN (Ret.); local historian Mike Miron, who personally recorded over 120 hours of maritime oral histories; Sarah Robertson; Jean Russo, historian of the Historic Annapolis Foundation; Bridget Shea; Susan Steckman of Annapolis Convention and Visitors Bureau; my mother, Gloria Freitas Steidinger, who taught me from a very young age to make every challenge fun, "even if it kills you"; Peter Tasi; Donald Trumpy; Sigrid Trumpy; Jack Schatz; Rich Williams; *Spinsheet* editor Molly Winans; and, most of all, my beloved husband, John P. Williams, Major, USMC (Ret.), without whom I could not have written this book. Finally, I extend my sincere gratitude to today's watermen, boat builders, sailors, marine tradesmen and graduating midshipmen—men and women who continue Annapolis's longstanding tradition of dedication to the water.

INTRODUCTION

It was still dark and near freezing on an early Thursday morning in late November 1874, and Annapolis's City Dock was the usual frenzy of activity. Oyster boats and schooners were stacked four or five deep against the bulkheads as the watermen unloaded their cargo onto the well-used wooden dock. The bulkheads had been recently repaired, but with cheap, weak wood that placed the dock in constant need of repair, perpetuating the waterfront's seedy appearance. There was a cacophony of voices of watermen and merchants, a mix of accents that included old Maryland and broken English, tinged with Irish, German, Greek and Italian. Black men and white men worked shoulder to shoulder in the no-nonsense way of the Maryland watermen. If they noticed the ice frozen on their boats and lines, the inches of frigid mud that reached past their ankles, the stench of the century-old Fish Market mixed with the city's sewer, which ran down the streets to the water, they didn't show it. Fishing, particularly oystering, was a lucrative business—a captain made four times what the average Annapolis worker made on land.[1] It was also, however, a tough business. Many of the men, particularly the oyster dredgers, spent several days at a time on their boats fishing in the Chesapeake Bay, suffering through brutal working conditions, the scourges of Mother Nature and the often violent rivalries with other oyster boats. In Annapolis, Maryland, in 1874, it was every man for himself.

Annapolis has a rich, celebrated and well-documented history that dates back to the earliest settlers in 1649. In addition to its superb geographic location for trade and travel, two major events in the seventeenth century were largely responsible for Annapolis's path to historical significance. In 1683, British rule designated Annapolis as an official port of entry that required all trade coming into and going out of the province to pass through the city. Twelve years later, Annapolis was named the new state capital, which had previously been St. Mary's in southern Maryland.

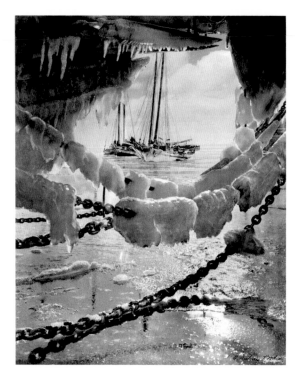

Oyster boats trapped on Spa Creek until the next thaw, 1936. *Courtesy of A. Aubrey Bodine, © Jennifer B. Bodine, www.aaubreybodine.com.*

Immediately following British rule, Annapolis was also designated for a short period of time as the capital of the newly formed United States when the Continental Congress met in the heart of the city from 1783 to 1784. During that time, the Treaty of Paris, which officially ended the Revolutionary War, was ratified by Congress. Also, General George Washington resigned his commission with the Continental army to emphasize the separation of civilian leadership and its military, an event that is honored at the city hall every year to this day. Four signers of the Declaration of Independence called Annapolis home, and the city's well-preserved downtown has one of the largest and oldest displays of high Georgian architecture in the country, dating back to the eighteenth century.[2]

Anyone looking for information on the well-documented history of Annapolis will find a host of options at the Anne Arundel County Public Libraries, Maryland State Archives, Historic Annapolis Foundation, county and state historic societies, the city's Convention and Visitors Bureau or even on the bookshelves of the people who live here. Annapolitans love their history as they love their city.

While these historically significant events set Annapolis apart from the few other equally old American cities and towns, important history was also

Advertising for oysters in Annapolis was not as flashy as in the much larger market of Baltimore. Everyone in town already knew who was selling and where, 1887. *Ad from the* Maryland Gazette, *courtesy of the Maryland State Archives.*

being made on the water. America's seaports are its windows on the world,[3] and Annapolis is no exception. While several historic events help map out Annapolis history, one constant has always been its orientation to the water.

Over time, Annapolis waters have brought the food and trade that allowed the first settlers to survive, record-breaking shipments of locally harvested oysters—"Chesapeake Gold"—and other seafood, significant boatbuilding and design, world-class luxury yachts cruising and racing during the Golden Age of yachting and generations of naval officers trained at the largest service academy in the world. Compared to the storied history of downtown Annapolis, its maritime history is sometimes rough, gritty and unattractive, with many of the events not recorded in court records, historical societies or libraries. Nevertheless, the city's maritime history is also brave, unyielding and awe-inspiring. The names of the men and women scattered throughout the colorful history of maritime Annapolis may not be widely known, but they are the foundation for what is an enduring and prosperous maritime community.

In 1874, around the time Thomas Edison invented the phonograph, the rapidly growing oyster trade consumed the city of Annapolis. Over fourteen million bushels of oysters were shipped out of Maryland during that year

alone, to places as far away as the West Coast and Europe, much of it via City Dock[4] in Annapolis. There was a handful of boatyards in the harbor turning out or repairing vessels for the ever-growing ranks of Annapolis watermen, boats such as the Chesapeake log canoe, the shallow-draft bugeye or the single-masted skipjack. Seventy-five years later, the number of Annapolis boatyards would grow to seventeen along the shores of Back and Spa Creeks. These artisans did not just build and repair boats but also constantly refined boat designs to best suit the needs of the people who worked, and later played, on the water.

Lying to the northeast of City Dock, the United States Naval Academy was not quite thirty years old in 1874. The academy changed the landscape of Annapolis, both socially and geographically. Before the end of 1970, the Naval Academy would grow from 10 to almost 340 acres of land, 63 of which were created by dredging dirt and muck out of the Severn River and Spa Creek. Waterfront band concerts, sailing regattas, power vessel trials, local

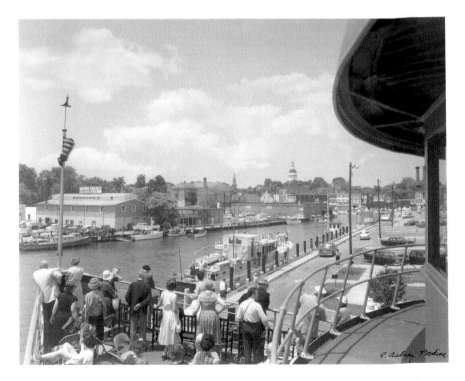

Packed with day-trippers, tourists and parties, ferries like the *Port Welcome* from Baltimore were a regular sight at City Dock. 1959. *Courtesy of A. Aubrey Bodine, © Jennifer B. Bodine, www.aaubreybodine.com.*

marriages and a steady influx of tourism are just a few events and traditions that have forever bonded the U.S. Naval Academy and its midshipmen to the town and people of Annapolis.

The widely popular sailing races of today were not even a dream of the watermen of 1874. Heading in from a long day of work on the bay, or perhaps during some rare time off, they would, however, often race their sailing work boats against one another. It is unlikely that anyone then imagined that Annapolis would become a world yachting destination, where the most luxurious of motor yachts were designed and built, or that, a few years later, Maryland's capital would host world races and regattas with some of the sleekest, fastest boats of the modern age, thereby earning the moniker "America's sailing capital."

For the earliest settlers of Annapolis, hard work and commitment to community were the best weapons to fight the almost constant adversity that they faced. Conflict, war, weather and competition would slow them down but would not stop their pursuit of a town of tolerance and self-reliance. In the more than two hundred years that followed, progress, the Industrial Revolution and the human error of overharvesting local seafood would both change the priorities of Annapolis and strengthen the community's commitment to its maritime culture.

From Waterfront Wilderness to City Dock

Annapolis on the Map—Official Port of Entry

Two years after the earliest settlers arrived across the Severn River at Greenbury Point, a boat builder or shipwright named Thomas Todd claimed one hundred acres that swept from the Severn River along the Chesapeake Bay to Carroll's Creek, present-day Spa Creek, and called it Todd's Harbor. The landscape surrounding Todd's new venture was a waterfront wilderness without a marked entrance, landing or dock. The cove that fed into Todd's Harbor was called Weathering Cove, today's City Dock.[5] Todd's nearest neighbors were Thomas Hall, who had about twenty acres near present-day Duke of Gloucester Street, and Richard Acton, who lived on one hundred acres close to the cove that still bears his name on Spa Creek.[6]

Thirty-two years later, in 1683, the young settlement was busy but tiny, consisting of about six families and a tavern and boatyard for its main businesses.[7] Things changed dramatically that year when British rule named it one of Maryland's official ports of entry, which meant that the selling and unloading of all goods in the province had to take place in Annapolis, without exception. The province was not a small area—it included Baltimore, Anne Arundel County's waterfronts (modern-day Edgewater, South River and West River) and all the "rivers, creeks, coves (saving the Patuxent River) thereunto."[8] While great news for Annapolis, it was also a good way for Lord Baltimore to keep an eye on the money coming in, since a significant portion of his income came from the tax levied on trade.[9]

Not everyone was happy about the designation, however. The already difficult, dangerous and time-consuming job of shipping became more so with the Annapolis detour. Its harbor had an extremely tight entrance and was surrounded by shifting shoals, or shallows, on both sides. A captain delivering

A History of Watermen, Sails & Midshipmen

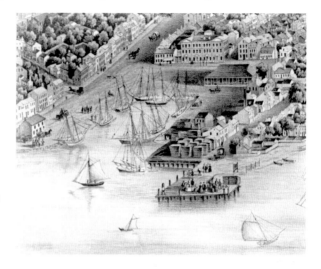

This 1858 illustration shows just one of many shapes that City Dock had over the years. Often larger and deeper in the 1700s, City Dock's water once reached today's Main Street. *Courtesy of the Historic Foundation of Annapolis.*

rum to Londontowne or tea to Baltimore, for instance, was significantly inconvenienced, even if his land-based merchant took care of the paperwork in town while the ship sat idle in one of the rivers waiting to unload. Following constant complaints from ships' captains and merchants, local British rule eventually offered them the option of having the tax collected out in the harbor.

While the settlement grew, the name of the town went through a few incarnations. The first settlement on Greenbury Point was called Providence. Once it spread across the Severn River to present-day Annapolis, it became the Town at Proctor's Landing and later, Anne Arundel Town, or Arundelton, after the wife of Cecil Calvert, the second Lord of Baltimore. In 1694, Annapolis received its new and final name the same year that it was designated the new capital of Maryland (previously St. Mary's City).

With the two important designations, Annapolis quickly became a hub for colonial life and business, and in just four years it grew to about 250 people, with forty buildings.[10] The city's first public ferry in 1695 was busy with trips to the Eastern Shore, a water route that cut in half an overland journey to places like Delaware or Philadelphia.

The magnificent multi-masted schooners were a constant presence in the harbor, even more so after 1694, when Maryland's earliest settlers were already trading with England approximately ten times a year.[11] Raw materials such as tobacco from the county and grain from nearby Windmill Point, a peninsula on today's Naval Academy grounds, were stored in warehouses along the southeast edge of City Dock, ready for shipment.

The city's politics, businesses and society would continue to grow and change, but its strongest common denominator would always be its maritime tradition.

SHIPWRIGHTS AND COLONIAL ANNAPOLIS

Annapolis did not develop into the major tobacco trading center that it had hoped to be. Tobacco was the foundation of its trade and even the settlement's form of currency. Unfortunately, Annapolis's "sotweed" was not up to the high standards of tobacco-rich Virginia.[12] Instead, Annapolis found its strength as a maritime center.

Beginning in 1695, the hardworking schooners doing trade with Annapolis were built or repaired at a designated area on the northeast side of Weathering Cove called the Ship Carpenter's Lot. This was prime real estate for anyone in the business of building or repairing ships, but it wasn't free. A shipwright had to use his space continuously for boat building and nothing else for the entire twelve-month lease. Long-time shipwright Robert Johnson was the very first to sign a lease twenty-four years later, and available research indicates that he was a man who did not waste any time.

Johnson picked his spot at the top of the Ship Carpenter's Lot, closest to the deepest water available, and immediately built two houses there. Like other successful businessmen in colonial Annapolis, Johnson diversified. He was not just a successful shipwright—he also had a small but successful farm, at least one other parcel of property and two more houses in town that he built. Just like today's entrepreneurs playing the stock market, Johnson also speculated on the various goods being imported to the city.[13] As shipwright, farmer and real estate developer, Johnson was an eighteenth-century version of today's business tycoon. Only three years after he opened shop on the lot, Johnson passed away, leaving behind a very large estate, which was fortunate for the Widow Johnson, as they had nine children, six of whom were fairly

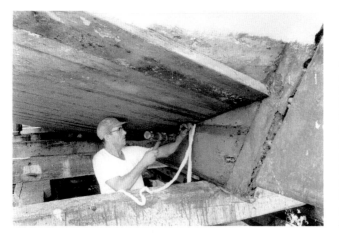

A modern-day shipwright caulks the seam between the keel and the first plank, one of the first places a skipjack leaks. The multitude of holes is from the wood-eating sea worm. Circa 1940s. *Courtesy of the Chesapeake Bay Maritime Museum.*

young.[14] For shipbuilding and construction materials, he left almost three thousand feet of pine and oak, which were extremely valuable given the scarcity of lumber in Annapolis at the time, and some iron that was likely hardware for his shipbuilding and house construction. His death may have been sudden, as he also left behind "a boat partly built" and "half a sloop."[15] Many years later, his sons and grandsons continued the Johnson tradition and became successful ship carpenters and merchants in their own right.

Robert Gordon was the next person to set up shop on the Ship Carpenter's Lot. He was not a shipwright, but a merchant, and likely sublet his space to a man named Samuel Hastings to fulfill the lease requirements. Unfortunately, Shipwright Hastings was either very unlucky or a bad businessman, as his year was fraught with difficulties. In 1729, he placed the first of three ads in the *Maryland Gazette*. The first was for a missing brass box and handle that he either lost or had stolen from him, last seen near "the stock of the city." The second ad was about his apparently desperately lazy servant, who was caught after running away and put back to work at sawing. Unfortunately, rather than continue working for Hastings, the servant intentionally cut off one of his own hands. The third and final ad indicates better news for Hastings with a notice of his launching of the ship *Snow* in December 1730.[16]

By the mid-eighteenth century, Annapolis had a reputation as the best ship supply and repair center on the entire Chesapeake Bay. The local paper in 1778 reported seventeen ships in Annapolis Harbor from as far away as Barbados, Amsterdam and, of course, England.[17] Ships' captains and merchants relied heavily on Annapolis for the necessary and frequent repairs to their ships from the wear and tear of ocean crossings and battling nature's fury. In the dangerous work of trade on the water, safety was always a factor for the captains, as reported in the *Maryland Gazette* on July 6, 1746:

> On July 6th, the schooner Peggy...bound for Annapolis with passengers, was struck by lightning...ten person lay for some time as dead. On recovering their conciousness [sic] they were seized with violent vomiting. The cabin was filled with a sulphurous [sic] smell.

One of the most remarkable descriptions of surviving violent weather involved the Maryland sloop *Endeavour*, which sailed from Annapolis on December 13, 1747, bound for the West Indies. Shortly after leaving Annapolis, she was hit with "exceedingly hard gales of wind," which ripped away all her masts, boats and rigging. Completely disabled, she tossed around the Atlantic Ocean for six months, eventually carried by the Gulf Stream to the Isle of Tiree near Scotland. Her owner had long given her up

for lost when he received an unexpected report from Edinburgh six months later with the news that the *Endeavour* was safe and had arrived in Scotland with the surviving crewmen, who were described as being "quite thin, and all as grey as Rats."[18]

Drowning, lightning, gale-force winds and being lost at sea for months were not the makings of a recruitment poster for colonial captains looking for crew. A sailor's life was rough, and the hard living landed many sailors in the county jail, or "goal," near City Dock. For many sailors, the relatively good wages were just not enough to commit their lives to the sea, and they deserted to become farmers. The idea that a life of farming would be easier than one at sea was not necessarily correct.[19] In fact, weather conditions in eighteenth-century Annapolis were harsh for everyone, as described in 1739 in a letter from Dr. Alexander Hamilton, a visitor to Annapolis, to a friend in England:

> *We have here in this country very hot weather in the summer time, of which you can have no idea. I write to you now in my shirt and drawers, with all the doors and windows open upon me to receive the breeze, and yet I sweat excessively…We are pestered with vermin of various kinds, such as muscettoes [sic], bugs and ticks, which sticking to the skin, plague one sufficiently and sometimes fester.*[20]

The severe winters in Annapolis presented the opposite extreme, as described by the extremely unhappy Dr. Hamilton in the same letter:

> *[Y]our breath will freeze upon the sheets in a night…Several people here are what they call frost-bit, and lose their limbs by gangrenes occasioned by the frost. A bowl of water or punch will freeze standing near a pretty large fire of wood, and sometimes as one endeavours to warm himself, he shall be roasted upon one side and almost frozen on the other.*

While Dr. Hamilton's descriptions may seem exaggerated, Annapolis winters in the eighteenth, nineteenth and early twentieth centuries were extremely cold.[21] The harsh weather often locked the bay in ice that kept all boats from entering or leaving Annapolis until March, when the ice began to thaw, as reported on February 18, 1904:

> *The harbor is completely frozen over and there is no track in the ice today… Capt. Martin found the Bay frozen from Sandy Point to Thomas Point… The present conditions are considered serious for shipping.*

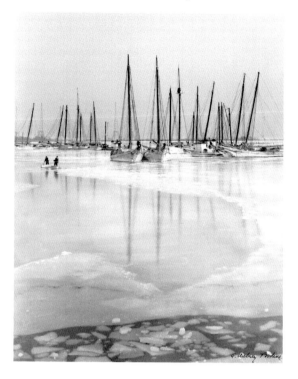

Oyster boats frozen between Annapolis and Greenbury Point, 1936. The two businessmen poling their way to shore are likely the boat owners. *Courtesy of A. Aubrey Bodine, © Jennifer B. Bodine, www.aaubreybodine.com.*

A ship's arrival during the colonial period was not something to set a watch or even a calendar by. Shipping schedules were more dependent on weather and tides than a captain or merchant's wishes or plans. Timing, however, was everything, and even the fastest ships could be delayed just outside of Annapolis because of the harbor's narrow opening between Greenbury and Horn Points. The passage was so much smaller than today's broad channel that many frustrated captains were forced to wait for days before the right wind carried them through the narrow channel and into Annapolis.[22]

Small boatyards sprang up around the Annapolis waterfront during the peak years for shipwrights, 1740s through 1750s, including William Roberts's boatyard on Dorsey Creek, present-day College Creek.[23] In addition to the work on multi-masted schooners, the Ship Carpenter's Lot and other yards like Roberts's were also building and repairing sloops, single-masted sailing vessels; and brigs, two-masted sailing vessels, square-rigged on both masts. Of all the busy shipwrights in Annapolis, Benjamin Sallier may have been the most colorful.[24]

Sallier had a reputation as a talented shipbuilder, but he also had a terrible temper that left him penniless and landed him in jail. A customer of Sallier's stopped paying him after an argument about how to build his boat. Sallier

sued for payment but lost the case. Out of money and in debt, Sallier was thrown in the county jail. A post by the local sheriff in the *Maryland Gazette* in May 1752 offers a glimpse into the trouble that Sallier faced:[25]

> *Broke out of Anne Arundel County Goal, Benjamin Sallyer* [sic], *ship carpenter by trade, sour looking fellow about 30 years of age, brown complexion, impudent, talks bold, wears handkerchiefs tied in a careless manner around his neck. Reward. Nathan Hammond, Sheriff*

Within a month, Shipwright Sallier was given a badly needed break:

> *This is to give notice that if Sallyer will surrender himself to me, he shall not again be put in prison for the debt for which he was confined. I would give him liberty to work out his debt and fees. Nathan Hammond, Sheriff N.B. A gentleman would immediately employ him to finish a vessel.*

There is no record of whether the sour-looking fellow with his carelessly tied handkerchiefs finished the ship and stayed out of jail.

The heavy traffic in and out of the Port of Annapolis was tracked by the local British customs officer. The entry logs of 1752 recorded that eighty-two vessels cleared Annapolis that year. Twenty-three of the ships were bound for the Caribbean; thirty-one for the British Isles; four for Africa, Europe and Madeira; and twenty-four for British North America. Commerce shipped out of Annapolis included tobacco, grain, flour, barreled pork and beef, peas, lumber and iron, while goods coming into Annapolis included rum, molasses and sugar from the Caribbean; convicts, slaves, sail cloth and tea from the British Isles; and gold, ivory and wine from Africa and Madeira, respectively.[26]

Shipping thousands of people as human cargo to Annapolis and the other Chesapeake colonies was big business. The trade originated in the early 1700s when British rule offered one hundred acres to any man with servants in an effort to settle Annapolis more quickly. Some servants paid the fare for the ocean crossing, and the ones who couldn't "indentured" themselves, entering into a work contract with ship owners or captains for a specific period of time, usually five to seven years. The captains or merchants then sold the servants to the highest bidder once they arrived Annapolis.

About twenty thousand convicts were also shipped to the Chesapeake colonies to serve their British prison terms here instead of in the overcrowded English jails.[27] With this latest addition of Annapolis's new "citizens," the number of thefts, arsons and violent crimes soared, and diseases brought

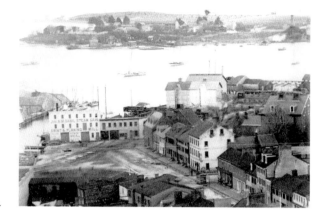

A view from City Dock toward Eastport. What looks like three roofs in the left corner is actually one building and two massive piles of oyster shells from Martin's Packing House. Circa 1890. *Courtesy of the Annapolis Maritime Museum.*

over with the convicts, such as yellow fever and something called "jail fever," spread through town.[28]

The different groups covered a wide range of people—dangerous criminals; vagrants; political and military prisoners principally from Scotland and Ireland; quite a few ordinary, everyday people; and a few true gentlemen by eighteenth-century standards, who, for one reason or another, felt it necessary to run for their lives. After the servant worked off his debt, he was often given a few things from his former master to get started in his new life, including clothing, a few tools and occasionally some land or a farm. About 150 years after it began, the flow of servants and convicts to Annapolis slowed with the increase of imported slaves, and blacks quickly outnumbered indentured English and Irish servants.

The majority of blacks came directly to Annapolis from Africa, with smaller numbers from the Caribbean and Virginia.[29] Kunta Kinte, the famous central character in Alex Haley's book *Roots*, arrived in Annapolis from Africa in 1667, four years after slavery was legalized in Maryland. The unfortunate business of importing slaves was not an organized effort by the colonies or England. Professional slavers sailed into Annapolis carrying only slaves, while other ships carried just a few with other cargo. In colonial Annapolis, the slave ships docked downtown, but since there was no official slave market, the men, women and children were usually sold on the decks of the ships.[30]

Despite the heavy shipping traffic, four things were working against Annapolis's successful trade—the dreaded sea worm that ate the ships' wooden hulls when there was a lack of fresh water flowing into City Dock to keep them away, the growing lack of timber crucial to the busy shipwrights, the slow decay of City Dock and the already too shallow inner harbor. Inevitably, Annapolis's lucrative trade began to migrate to Baltimore,

despite the standard requirement for every ship to stop in Annapolis to pay its tax.[31] The tax detours didn't bring any actual business to Annapolis, and by early 1770, Baltimore had surpassed Annapolis in trade and Annapolis shipwrights fell behind their competition, the busy boatyards on the nearby West and South Rivers.[32] The city would have to be content with its new reputation as the center for Maryland politics and society.

As is wont to happen with successful trade, taxes on the American colonies began to increase at an alarming rate. The Navigation Act demanded that colonists trade only with England using just English ships. The busy shipwrights' hammers fell silent across the colonies and trade profits evaporated.[33]

The colonies complained vehemently, but their words fell on deaf ears. Lacking proper representation in Parliament three thousand miles away, Annapolis and the other American colonies began to take matters into their own hands. "No taxation without representation" was the colonies' rallying cry when America entered into war with its ruler and protector.

The Revolutionary War gave Annapolis a temporary boost when it became a major supply depot for the war, but the war would not be enough to sustain growth.

The British left Annapolis at the end of the war and so did the city's valuable designation as one of Maryland's ports of entry. The Severn River outside Annapolis Harbor was still a good anchorage for the larger ships, but getting inside City Dock continued to be a serious problem. Ships got hung up on the shoals outside City Dock, and the destructive sea worm was still decimating ships' wooden hulls. In 1787, land was created for the new Market House, built at the foot of Church Street, present-day Main Street, which narrowed the City Dock considerably.[34]

A postcard from 1906 titled "Market Space" shows the park and Market House. *Courtesy of the Chesapeake Bay Maritime Museum.*

Meanwhile, Baltimore businessmen were busy promoting their city's growing maritime trade, and it flourished. Baltimore received its own customs house, and almost overnight, the requisite stop to Annapolis was eliminated. By the 1790s, Annapolis was still a political and social center, but Baltimore was Maryland's leader in maritime trade and began to set its sights on becoming Maryland's capital. After one hundred years as a vibrant and successful seaport, Annapolis's water trade began a steady decline that would last until well after the next war in 1812.

1800s—A SLOW REVIVAL

Following the War of 1812, America was finally free to trade without foreign interference, and its seaports began to thrive. Maryland's exports skyrocketed, but Baltimore still had much of Annapolis's share, leaving the crumbling and neglected City Dock falling into further disrepair. Maryland's capital was becoming a backwater town compared to the wildly successful and thriving port of Baltimore. A visitor to Annapolis, Lieutenant Francis Hall described the bleak Annapolis landscape in the *Maryland Gazette* on December 25, 1816:

> [D]*uring the colonial regime, Annapolis was the center of fashion to all America…of rank and family, who brought with them a taste for social elegance…*[and] *since Annapolis has fallen into decay,* [they] *have become residents of Baltimore.*

Over the next few years, Annapolis tried to rally and lobbied European merchants who were looking to continue trade with America.[35] Annapolis was certainly available, and with its ideal location on the Chesapeake Bay the city began a slow recovery as a major port. But it wasn't until the United States Naval Academy was established in 1845 that real prosperity returned to Annapolis. Ironically, Annapolis had fervently lobbied officials in Washington, D.C., for twenty years to host a new naval school in an effort to boost the town's economy, but it was actually because of Annapolis's quiet existence that it was chosen over larger cities like Philadelphia.[36] The U.S. Naval Academy gave Annapolis the push it needed, and then some. New buildings, expanded property, social networking, concerts, sports, sailing and a flood of nattily dressed midshipman made Annapolis synonymous with the Naval Academy to the present day.

While the new academy was preparing for its first class of forty midshipmen, a new industry was beginning to occupy Annapolis, an industry that would bring great wealth to the city but also horrific violence on the Chesapeake Bay.

Though it was primarily a survival food for the earliest Annapolis settlers, the Chesapeake Bay oyster was on its way to international demand. New England fishing boats entered the bay in 1811, looking for oysters after depleting their own oyster beds, and they brought with them a new invention to scoop massive amounts of oysters off the bottom of the bay with a single stroke—the heavy metal dredge. With the dredge's alarming efficiency, a local commerce accelerated into a multimillion-dollar international business almost overnight.

The sudden economic boom from the oyster trade in the mid- to late 1800s also brought a sizeable increase in Annapolis's population, and Maryland's state capital was busier than ever. City Dock was the center of all the oyster action, and a person could walk from one side of the City Dock to the other just by stepping boat to boat. Oyster packinghouses lined City Dock, with piles of spent oyster shells reaching as high as a one-and-a-half-story building. Steamship ferries to and from Annapolis were packed with passengers traveling regular routes to Baltimore and the Eastern Shore and points in between. No longer on life support, Annapolis was enjoying a steady recovery and getting stronger. It was time to take on Baltimore and recover some of the lost trade, as seen in this item from the *Maryland Gazette* on January 28, 1855:

> *For more than a week past, the ice has prevented steamers and other vessels bound to Baltimore from reaching their destination. As usual, they have had*

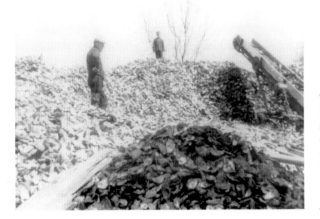

The young son of a McNasby office worker stands on top of a pile of discarded shells behind the oyster packing company while Justin "Chuck" McNasby looks on. April 1952. *Courtesy of the Annapolis Maritime Museum.*

to put in here to land their passengers…The detention of passengers and the
loss of merchandise, which occur so frequently, are strong arguments why
Annapolis should be made a sort of seaport for Baltimore.

The city's trade was still heavily dependent on the schooner, the first large common ship on the scene in colonial Annapolis. These large ships carried tobacco, grain, fish of all kinds from the bay and various produce, such as watermelons grown on Anne Arundel County farms. But when it came to dredging for oysters, the schooner was not the best design. Oyster boats needed to draw less, which refers to the amount of boat below the water line, to get into the shallows where the oysters were. They also needed to be as sturdy as a schooner but with decks lower to the water, called freeboard, to ease the burden of raising the heavy dredges onto the decks. The new boats were cheaper to build than the elaborate schooners, which cut costs for the working watermen. The money to be made in oystering was enough motivation for carpenters up and down the bay, and soon the bugeye, a two-masted, flat-bottomed boat, and then the skipjack, a single-masted boat with a huge mast and extra-long boom, were seen all over the bay, City Dock and the growing number of Annapolis boatyards.

By the mid-1800s, Annapolis's City Dock was packed with boats unloading seafood, produce and goods, which filled the modest and odorous Fish Market at the head of the dock, as well as rickety warehouses and packing sheds that surrounded the three sides of City Dock. The Market House was the center of activity and the focal point of the waterfront, and it remains somewhat of a gathering spot today, more than 150 years later.

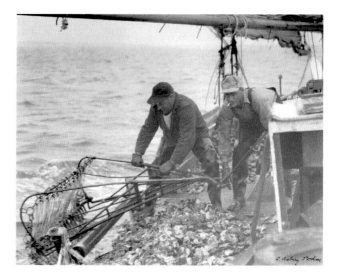

The windlass powers the dredge up to the boat, but it still takes manpower to bring the heavy load onto the deck. Circa 1940s. *Courtesy of A. Aubrey Bodine,* © *Jennifer B. Bodine, www.aaubreybodine.com.*

CITY DOCK, FISH MARKET AND MARKET HOUSE

Despite a deep and welcoming harbor, keeping Annapolis's dock useable for boat traffic was a constant struggle since its beginning as Weathering Cove. The busy waterfront was a mess. It suffered from excessive debris—runoff from the town that included sewage, silt that kept the water narrow and shallow and the poorly constructed wharves with cheap bulkheads that consistently gave way on either side. City Dock could not support the important larger ships crucial to profitable trade. A French visitor described the dock during his visit to Annapolis in 1765:[37]

> [S]hips of any burden can come up this river, and could formerly come close to town but this bassen [sic] is almost filled with dirt for want of a little care. However, the harbor is so good otherwise that the ships don't feel any great inconvenience from the loss.

When Baltimore became the port of choice, few people cared about the dirty and increasingly useless dock. It was a place for the rugged business of shipbuilding and repair and the often rough, crude watermen who made their living on the water. The collective dirty and difficult work being done at City Dock was a far cry from Maryland society and the marbled steps to the state's general assembly just a few blocks up the hill.

Dilapidated or not, City Dock was still the center of commerce, and the city's fiscal health depended on it. To clean, deepen, widen and make City Dock safe, it was going to take money, and the city sponsored the first of many legal lotteries to raise the funds in 1753. Several laws were also passed to help improve the dock's overall image—the removal of stones, timber and bricks lying nearby was required, and it was no longer permissible to fire a gun across the water or to bathe in it (although one hopes that common sense would have prevailed there).[38] The maritime captains, crewmen and merchants who worked at and hung around City Dock were not always law abiding. In the 1750s, dead bodies began to appear in City Dock, reportedly thrown overboard by ships' captains who couldn't be bothered with the trouble and expense of a more traditional burial, as reported in the *Maryland Gazette* on September 6, 1759:

> Sunday last the body of a man was found floating at the mouth of our Dock; and it is supposed to have been flung overboard from some ship in the river. A scandalous practice; but of late, a very common one. It is a pity, but the authors could be found and punished.[39]

A History of Watermen, Sails & Midshipmen

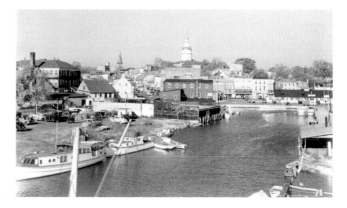

City Dock with a new bulkhead at the head of the dock, but the sides remain in disrepair. Circa 1936. *Courtesy of the Maryland State Archives.*

Unrecognizable today, this is a view of the end of Shipwright Street in downtown Annapolis in the early 1900s. *Courtesy of the Annapolis Maritime Museum.*

In over two hundred years, the physical shape of City Dock changed drastically many times. It appeared to be struggling to keep up with the city's own changes, from being the wealthiest town in Maryland to a sharp decline in its maritime trade after the Revolutionary War, only to rebound and then skyrocket after the Civil War, when the world discovered Chesapeake Bay oysters. By the late 1870s, land around the dock had slowly crept into the water, making it so narrow that smaller boats were used to supply the warehouses, sheds and Fish Market around the dock by retrieving the catch from larger ships anchored out in the harbor.

Eventually, the city had a wharf built across the head of the dock, where the building line of today's Market Space sits, to berth the bigger boats, and City Dock quickly became a home port for the growing oyster fleet.[40]

The large numbers of different boats at City Dock in the late nineteenth century that were loaded with oysters, fin fish and crabs went to the Fish

Market at the head of the dock, the center of Annapolis fish trade from 1890 until the city tore it down in 1930. It was partially built on pilings to hang over the water so that the watermen could pull right up to the back and sell their catch without getting out of their boats, a sort of precursor to the modern-day drive-through. After buying the fresh catch from the back of individual stalls, the merchants then cleaned the fish and dumped the waste back into the water before selling the fresh catch to customers from the front of the stall. Selling fish was brisk business in Annapolis in the early 1900s, with a tremendous variety and size of fish for sale. Shad with the roe intact sold for less than fifty cents, and large oysters cost less than a penny a piece.[41] When the Fish Market was torn down, the fish merchants sold their daily catch from the Market House, along with other merchants selling farm produce, beef and other goods. Around the same time, strict new laws were passed for safer handling and disposal of the fish, oysters and crabs. For instance, the tossing of fish waste into City Dock was no longer allowed.[42]

The original Market House was deeded by local British officials in 1696 and built to hold a weekly public market and an annual fair. It was rebuilt in 1798 and would be built again several times until the latest and eighth incarnation in 1857 where today's Market House stands. Of all the goods

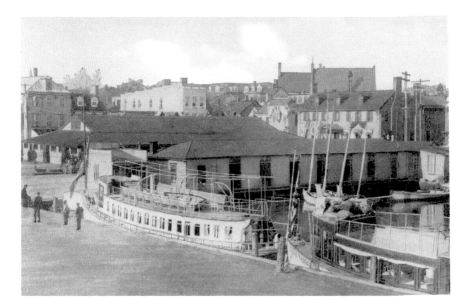

A postcard of City Dock from 1907–15, with tour ferries and the Fish Market. Fresh crab cakes were made and sold from the small cook sheds on either side of the Fish Market. *Courtesy of the Chesapeake Bay Maritime Museum.*

that were for sale at the downtown market, only fish and oysters were allowed to be sold any day of the week.[13]

For almost 150 years, watermen could be seen hanging around City Dock while their catch was sold at the Fish Market or Market House. The dock was their social and business headquarters, but they were not a group known for fashionable dress or polite small talk. A resident of Annapolis and regular Fish Market customer, Hildegarde Hawthorne described the market in 1917:

> *In shining rows and heaps lay the flashing catch of the sea. Heaped in baskets were oysters…packing away barrel upon barrel of the famous Chesapeakes. Salty men hung about, wearing battered hats and blue shirts, and mumbled to each other, indifferent to the rest of the world, as is the fashion of elderly sailor and fishing folk.*[14]

For many years, the City Dock was not properly maintained, and the conditions worsened into the twentieth century, with sewage, runoff and floating debris from occasional storms. Sporadic attempts continued to improve the dock, but for many reasons, they were ineffective. In an interview with Annapolitan Bobby Campbell conducted by Mame Warren that appeared in the book *Then Again…Annapolis 1900–1965*, Campbell explained the somewhat warped ecological cycle of City Dock:

> *The City Dock was a great cesspool, the sewer lines went down to the end of every street, and they dumped in Spa Creek…all the sewer lines, all the sewage…Talk about ecology; the alewife would feed on the sewage. The bluefish would feed on the alewives. We'd go down and catch the bluefish and bring them home to fry them and eat them.*[15]

City Dock would be known as the grittier part of town until the 1950s, when sailing and boating enthusiasts slowly began to outnumber Annapolis watermen. The city's new business of tourism brought significant improvements to the dock, including new and reinforced bulkheads and a number of boat slips for the growing number of visiting pleasure boats. Annapolis City Dock was given a high shine and was ready for its new role as runway for the steady pageantry of boats parading up and down the dock, nicknamed Ego Alley.

THE WATERMEN

Annapolis Frontiersmen

We found…abundance of fish lying so thick with their heads above the water, as for want of nets, our barge driving amongst them, we attempted to catch them with a frying pan, but we found it a bad instrument to catch fish with. Neither better fish, more plenty of variety, had any of us ever seen in any place, swimming in the water, than in the Bay of Chesapeake, but they are not to be caught with frying pans. But our boat by reason of the ebb, chancing to ground upon many shoals lying in the entrance, we spied many fishes lurking amongst the weeds on the sands. Our Captain, sporting himself to catch them by nailing them to the ground with his sword, set us all a fishing in that manner. By this device we took more in an hour than we all could eat.[46]
—*Captain John Smith, 1600s*

SEAFOOD'S HUMBLE BEGINNINGS

As it was in every other seventeenth-century colony, food was always on the verge of being dangerously scarce for the Annapolis settlers. Just a few years before they arrived at the waterfront wilderness, a similar settlement in Virginia had been eliminated by starvation and infection. Fortunately, much of the crucial nutrition for the colonists was provided in the shallow waters that surrounded them, with an abundance of oysters, crabs, terrapin turtles, clams and many varieties of fish.

Estuaries, bodies of water where fresh and salt water mix, are among the most productive environments on earth, and the Chesapeake Bay is the largest estuary in the country. People's preferences for seafood from the Chesapeake Bay shifted so dramatically over three hundred years that it is almost comical.

Diamondback terrapin turtles were plentiful in the eighteenth century. In fact, they were so abundant that in 1797, Maryland law made it illegal for

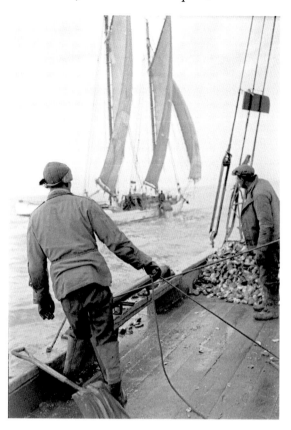

Two watermen take a moment to check out the competition. Note the heavily patched sails. Circa 1950s. *Charles E. Emery photograph.*

slave owners to feed their slaves "this cheap and unpalatable food, more than three times a week."[47] Given the status of black slaves in the colonial era, the steady diet must have been quite burdensome. Terrapin rose to the ranks of a nineteenth-century delicacy, and cream of terrapin soup, a recipe that includes three terrapins, heavy cream, sherry and six chopped hard-boiled eggs, was a local favorite in the finest Annapolis restaurants and homes.

The Chesapeake blue oyster may have had the most meteoric rise to stardom. Local Indians, who archaeologists believe had been eating oysters for as long as they had lived near the Chesapeake Bay, likely introduced oysters to the Annapolis settlers. Oysters were an early health food, with protein, many vitamins and most minerals. Their abundance and size were extraordinary, with one variety measuring up to thirteen inches long. But for the earliest colonists, oysters were considered a hardship food and were eaten only as a last remaining option when faced with starvation.[48] Oysters were also popular manure on Maryland farms, and the shells were ground for brick mortar and used as flux in local smelters for making iron.[49] Years

later, oyster shells would cover Annapolis roads as an early paving material. The well-known Maryland oyster trade started modestly and early. Toward the end of the Revolutionary War, ads for raw and pickled Maryland oysters started to appear in cities from Boston to Williamsburg, and an ad for "oysters and malt beer served by a tavern near the Dock" appeared in the *Maryland Gazette* on November 8, 1787. Beginning after the Civil War, the "Chesapeake Gold" would climb to the height of international culinary popularity, when it became impossible to supply oysters fast enough to meet demand.

Shad was also in abundance in eighteenth-century Annapolis, but since it was available to everyone and was so difficult to eat, with its hundreds of little bones, it was a fish eaten only by the very poor. It took two hundred years, but twentieth-century society eventually discovered the rich, sweet and slightly nutty taste of its roe, and its popularity soared. A favorite colonial recipe for shad roe exists today: flour-dusted roe sautéed in bacon grease for just a minute and served with the fried bacon on top.[50]

Stories abound of the Maryland crab crowding every river and stream and the shallows of the bay up until the twentieth century. Its size was once remarkable—one bay variety measured an astounding twelve inches long by six inches wide, containing enough meat to feed four men. The mental image is almost too much for today's crab lover, who is content with the current legal size of a measly five inches. The crab was easier to catch than other seafood for early Annapolis residents because it didn't require a boat, as it thrives in shallow water. Size, abundance and an easy harvest mattered little to seventeenth-century Annapolis, since the crab was considered even lowlier than the much-maligned oyster. The colonists' strict conservative eating habits, brought over from England, were gradually put aside, and crabs became accepted in the late eighteenth-century as something a well-mannered person could legitimately eat in public.[51]

Hard crabs were harvested during the nineteenth and early twentieth centuries using long lines, called trot lines, baited with salt eels attached to the string in intervals. It was a dicey process of snagging the caught crabs in a net while they were hanging off the eels. The best catch was the male crab, called a "jimmy," which was over two years old and the largest. Catching crabs evolved in the 1940s to an easier method of using twenty-four-inch cubed pots made of galvanized chicken wire, typically baited with pieces of the fish menhaden. The fragile soft crabs, known as peelers, are caught during their molting process but can be very difficult to find, as they molt in the thick, protective grasses of the bay's rivers and creeks. Their delicate taste, as well as the ease of eating the soft crab, shell and all, without the usual messy hard shells to wrestle with, made demand for the soft crab skyrocket in the early

Tongers and pleasure boats crowd City Dock at a time when the number of pleasure boats began to match the number of work boats. *Courtesy of A. Aubrey Bodine, © Jennifer B. Bodine, www.aaubreybodine.com.*

twentieth century. Suddenly, crabs were no longer just for picnic tables and summer outings, and the soft crab became high fashion, offered only in the finest local restaurants and introduced to the knife and fork.

Fish were a staple for the earliest colonists, but despite their great variety and abundance, not a single fish was exported from Annapolis for more than twenty years. There were regular shipments of tobacco to England from the earliest seventeenth-century settlers, but it would be another eighty years before barrels packed with herring began the colony's fish trade.[52] For two hundred years, it didn't take luck or talent to catch fish in the water around Annapolis. But for maximum efficiency, early commercial fishermen used large nets, such as a haul seine (a large net used to surround a school of fish and then drawn together to trap the fish and hauled on board) or a pound net (a net held by stakes pounded firmly into the bay's bottom). The most popular fish for sale at the Fish Market were striped bass or rockfish, shad, croaker, trout and white perch. After its peak in the 1880s, commercial fishing around Annapolis continued at an alarming rate, along with concerns of overfishing, as fishermen worked to meet the demands of the country's growing population.

In the beginning, it seemed as though the Chesapeake Bay had an inexhaustible supply of seafood. With the rise in popularity of each catch

came the unfortunate tradition of overharvesting, ultimately resulting in a steady decline in the population of each seafood. Over time, the Annapolis legislature enacted different laws aimed at conservation to help stay permanent damage, but on and off the water, each law received mixed results and support.

THE GUTS AND GRIT OF THE EARLY WATERMEN

Like other American colonies its size, Annapolis had two classes of people—the gentry, who made their money in trade, and the laborers, who, like the watermen, provided the goods to sell. Annapolis was the richest colony in Maryland, and long before a middle class emerged, the class difference was observed by John Rumsey, visiting from Delaware, in a letter dated November 1799:[53]

> *The gentry of Annapolis are divided into two classes. In the first are comprehended all those who have rank and fortune. They live in great splendor and in their society you have elegant manners and refined conversation, but very little amusive relaxation. The second class is composed of those whose wealth is not above mediocrity...The greatest objection to this class is that they are addicted to cards. The women are absolute gamblers, and while engaged in the game are bereft of every female attraction.*

Annapolis thrived with its reputation as a center of politics, wealth and gracious living, and some of the city's most successful residents were the local merchants in the growing fish trade. The hardworking men who provided the fresh catch had little or no wealth and definitely no standing in Annapolis society. Former slaves, convicts, immigrants and the very poor made up the majority of the earliest local watermen. Many poor white farmers joined the ranks on the water when land became too expensive and the tobacco trade unreliable.[54]

The word "waterman" may date as far back as 1400, but it appears more clearly in 1549, with a reference to a Tudor squire in England who "did buy of John Marteyn, Waterman oon hundereth and syxe bussels of oysters." This suggests that the word traveled over with the earliest colonists. Whatever the origin, the word "waterman" was used in Annapolis to describe the men who turned to the water for their work and food.[55]

To be a Maryland waterman, a man did not need to take an entrance exam or a U.S. Coast Guard qualification course, have a high school diploma or even know how to read or write, yet a hardworking waterman

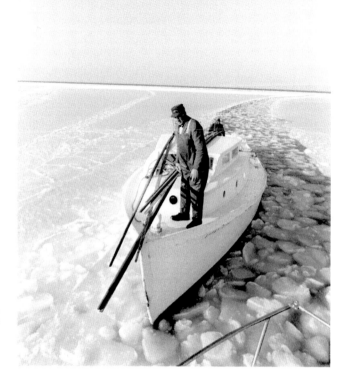

Tongers followed the state's steel icebreaker into the bay for another day's work oystering. Circa 1960s. *Photo by Robert DeGast, courtesy of Chesapeake Bay Maritime Museum.*

made a lot more money than his peers who labored on land. However, the personal cost was steep. Fishing in the bay and its rivers and creeks during the harsh winters and humid summers, twelve to fourteen hours a day, was backbreaking work. The often brutal conditions and increased competition between watermen made them impatient, coarse and not averse to violence if provoked. Home base for many of Annapolis's hardworking and hardened watermen was City Dock. It was a rough place in the early years, and the *Maryland Gazette* reported on many of the crimes committed around there, such as this item from April 26, 1759:

> *Yesterday, the dead carcass of a man was found drove on shore in this town; and this day another near the town; this is the fourth of the sort which has happened within a few days. Tis a pity the authors of such inhuman and scandalous burials from on vessels…could not be detected and punished. For beside the baseness of such actions, they occasion much trouble and expense, which might be easily prevented if (they) would behave like Christians and do as they would be done by.*

More than one hundred years later, the waterman's environment had not changed much, as reported in the *Maryland Gazette* in March 1887:

> *Jacob V. Dolman, Captain of the oyster schooner, Oliver M Ruark, was brought into Annapolis on the charge of killing William Stanley, one of his crew, in the Chesapeake...Bartley and Stanley, two of the crew, were afraid the boat would turn over, and lowered the sail two or three times against the Captain's order. On the last time, the Captain shot and killed Stanley.*

Little of life lightened the difficult conditions for the watermen over the years. Each generation faced its own challenges, and the overall attitude of watermen was fatalistic—they lived hard and not very long.

The most typical watermen were tongers, named after the long, pine-handled, scissor-like tool with heavy iron scoops at the end that they used to pluck oysters off the bottom of shallow waters. Tonging was likely the most dangerous and physically demanding of all the fishing done on the bay. The tongs weighed about thirty-five pounds when empty and averaged eight to thirty-five feet long, but they could be as long as a three-story building is high. Tongers generally worked standing precariously on the edge of their boats and were in constant danger of freezing from the continuous splashing water during the winter season, made worse by the constant motion of the water. Without a cabin or cover on their boats, the early tongers were virtually unprotected from the elements. Severe cramps and an almost constant fatigue plagued the tongers as they bent over the culling board spread across the width of the boat, separating the cold, wet and sharp-edged oysters. The invention of the patent tongs in 1887, with its overhead apparatus and cable to help lift the tongs out of the water, made work a bit more tolerable for the tongers.

For as long as there have been watermen in Annapolis, there have been African Americans among them. Slaves who gained their freedom in the late seventeenth century were among the first. Areas with the highest concentration of blacks were usually waterfront, closest to the best fishing grounds. Up until the 1950s, fishing on the bay was restricted to county and city residents, providing valuable opportunities for blacks who were free and in bondage.[56] For the watermen, there was less segregation out on the water than on land—blacks and whites often worked together, despite heavy criticism from the white business leaders and officials on the mainland. Determined to keep the race lines well defined, Annapolis legislators passed a law in 1842 that made it illegal for a free black to own any property,

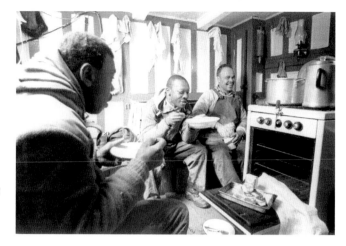

A skipjack crew below for chow. The painted paneling is fancier than on a typical skipjack. Notice the common kitchen tool, the screwdriver, hanging from the stove. *Photo by Robert DeGast, courtesy of the Chesapeake Bay Maritime Museum.*

including his own fishing boat.[57] This law was overturned, and by 1882, quite a few of Maryland's oyster licenses, particularly for tonging, were held by African American men from Annapolis. Because of the relatively good money to be made oystering, a middle class of African Americans emerged in waterfront areas in Annapolis, such as Eastport across Spa Creek. Each generation gained more ground—the first worked as hired crew; the next owned its own boats and hired its own crews.

In the warmer off-season, many of Annapolis's oystermen returned to farming or harvesting crabs. There were also many weekend watermen, as there are today—men who had regular jobs during the week, such as laborers at the Naval Academy, who fished on the weekends to augment their incomes.[58]

Women were not allowed to be watermen in the seventeenth, eighteenth and nineteenth centuries, unless widowed and very poor. Those two unfortunate designations allowed for the colonial woman to tong for oysters and not pay the requisite license fee. The law would be amended later to include preachers.[59]

Only on the Chesapeake—The Oystermen's Boats

The beautiful sailing work boats, such as Chesapeake log canoes, bugeyes and skipjacks, are modern romantic images, but as the foundation of the exhausting and often life-threatening business of oystering, they were anything but glamorous to their owners. The different boats, all distinctive to the Chesapeake Bay, were a series of improvements on the first, the Chesapeake log canoe.

The Chesapeake log canoe was a design that came from the Indians, who taught the earliest settlers how to hollow out and then burn the inside of a large tree. It quickly evolved into the colonists' version, which was also a dugout, eighteen to twenty-five feet long, but made from two to four logs secured together instead of one. The Chesapeake log canoe was the fastest work boat, but it was also the most unstable (also called tender), making it potentially dangerous during the choppy winter months on the bay.[60]

The first New England fleet of oyster boats that sailed from Connecticut to raid the Chesapeake Bay of its oysters brought with it the dredge, the strange but powerfully efficient device made of steel rods, chain and rope netting. Overnight, local Chesapeake oystermen were taught how to scoop hundreds of oysters off the bottom of the bay with one fluid motion. Since the largest oyster beds are found in water less than forty feet deep, the bay was the perfect target, with its average depth of about twenty-one feet.[61] The narrow, tender Chesapeake log canoe proved to be not the best design for the heavy metal dredge.

The Chesapeake log canoe was vastly improved with the design of the bugeye, likely the most popular of the oyster boats original to the Chesapeake Bay and called "perhaps the only purely American vessel."[62] The origin

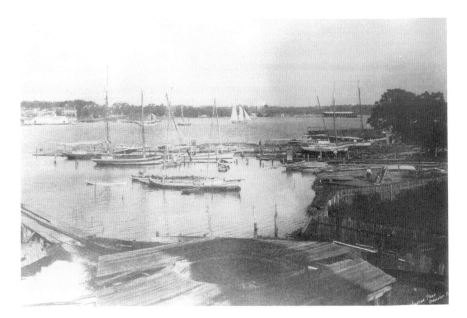

Looking from Heller's boatyard in Eastport toward the naval academy. The large, dark-hulled boat at the USNA wharf is the USS *Santee*, and the academy's schooners are behind the wharf. Circa 1889. *Courtesy of the Historic Annapolis Foundation.*

of the name remains in constant dispute, but according to a book on the Chesapeake bugeyes, it got its name from an "eye" or circle on either side of the bow, designed to ward off evil spirits.[63] Other theories speculate that the name originated because the two holes on either side of the bow look like bugs' eyes, the maneuvering of the boat was so good that it could "turn on a bug's eye" and the popular version that it came from *buckie*, a Scottish word that may or may not mean "oyster shell."[64] Built for the oystermen in the oyster heydays of the 1880s, it is a heavy boat, flat-bottomed with a manual centerboard to allow it to get into the shallows easily and still sail well in deeper water. Sturdy enough for the metal dredge, the bugeye was typically over fifty feet long. The early bugeyes were carved from five or more logs with framed topsides, but as large timbers became scarce, they were frame built with milled planks.[65] The bugeye can have more than one mast, and the entire body is decked over except for a small cabin and the hatches. The large amount of available space worked well for oystering, with room for accommodations below and a deck large enough for the dredge, the windlass (a man-powered winch to raise the loaded dredge) and of course, the oysters. The lengthy bugeye was a challenge to sail, although it was less difficult than its predecessor. Experienced captains know their boats as well as they know themselves, and with wind as their only power, bugeye captains maneuvered their boats seemingly with the greatest of ease through the constantly changing depths and shifting winds of the Chesapeake Bay. Robert and George Barrie, brothers and prolific writers on sailing the bay, share the following account from Annapolis in 1909:[66]

> *I have seen two baymen back a large bugeye for several hundred yards out of the thickets of vessels in Annapolis harbor, and this simply wonderful feat excited no surprise among the neighbors. They are certainly expert sailors in line…[and] wonderful at handling the typical bay craft of fifty to ninety feet.*

Ten years after the bugeye came the beloved skipjack, also known as a dead-rise, a term for the low, wide *V* formed by the hull that makes the boat sail smoother in rough weather. The skipjack had a single mast that raked, or leaned back, and a shallow draft, also known as draw. Skipjacks were typically sixty feet long and featured an uncomplicated sailing rig so that they could be sailed by just one man, leaving the rest of the crew to focus on the oyster bounty. One of the rules for building a skipjack was for the mast to be as high as the ship is long, plus its beam, or width. This meant an extremely tall mast, with a massive sail area to harness as much wind as

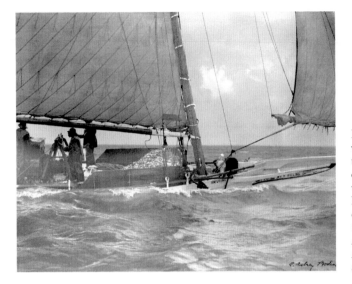

In this award-winning photo, the *H.M. Willing* continues dredging with a good load of oysters onboard. 1928. *Courtesy of A. Aubrey Bodine, © Jennifer B. Bodine, www. aaubreybodine.com.*

possible to drag the dredge, even in light wind. There are many origins of the name, but one popular local version derives the name from the way the vessel "skips" over the waves.[67] While a common sight for many years, fewer than twenty-five skipjacks remain today of the more than one thousand on the Chesapeake Bay in the late 1800s.[68]

"ARS'TARIN'"—ANNAPOLIS'S GOLD RUSH

When the Chesapeake's oyster industry began to skyrocket into a multimillion-dollar industry in the late 1800s, the same get-rich-quick scenario and "shoot now, ask questions later" attitude of America's gold rush on the Western frontier took hold.

The massive Chesapeake Bay's eleven thousand miles of shoreline, which is greater than the entire U.S. West Coast, was shared by Maryland and Virginia watermen, but not easily. Since the colonial era, the two states have argued bitterly over how to divide the bay equally between them. Even after three years of federal arbitration in 1877, disputes continued long into the next century.[69] Despite the longstanding and often bitter disagreement, the two could agree on one thing—there was no room on the bay for interlopers. The number of Northeast schooners dredging the Chesapeake Bay for oysters increased steadily following the War of 1812 and they had to be stopped.

Oyster merchants and watermen alike protested against what they called the "plundering Yankee 'drudgers.'"[70] A law in the 1850s that banned

nonresidents from oystering in the Chesapeake Bay caused an overnight population boom in Annapolis and other Maryland waterfront towns as New England fishermen began to call Maryland home. Others openly broke the new resident law, and those who were caught faced the inconvenience of buying back their seized work boats at auction. As reported in the *Maryland Gazette* on November 2 and 9, 1854:

> *Justice Stalker issued a warrant for the arrest of Christian Robinson, Captain, and* [his] *crew of the schooner* Beacon, *of Philadelphia, 27 tons burthen, owned by Joseph Collins of that city. They were charged… with violation of the Oyster Laws, and were fined and committed in default of payment. The* Beacon *was taken, and is advertised for sale under the law above referred to. The captain and crew have paid the fine and costs, and have been discharged.*

One week later, "the schooner *Beacon*, seized for violation of the Oyster Laws, was sold yesterday. She was purchased by her former owner, Joseph Collins, of Philadelphia, for the sum of $296."

The amount of money that was made from oystering at that time is staggering. During the late nineteenth century, watermen were paid forty-five cents per bushel, and the merchants sold the oysters for twice that. A relatively low annual harvest of over eleven million bushels meant that Maryland oysters were a $5-million-a-year industry for the state's oystermen. The state was also making money, taking in $70,000 a year just in license fees. The dwindling economy of post–Civil War Annapolis recovered and was booming. Annapolis's "gold rush" would not last, however. Maryland's oyster harvests peaked at fifteen million bushels in 1884 and fell to fewer than ten million just six years later.[71] Overharvesting was severely damaging the industry, and its very survival was threatened. In one of the few times that the watermen and state officials would agree, both groups decided that it was time for more legislation. What had happened in the waters of New England must not happen in the Chesapeake Bay.

OYSTER LAWS V. THE MAD OYSTER RUSH

Meanwhile, it was 1869 and one of the harshest winters on record, but Captain Hunter Davidson was impatient to get back out on the bay. He had a tough job to do, one in which any day could be his last. Captain Davidson was a lawman, commander of the newly formed Maryland Oyster Navy, and

was charged with the nearly impossible task of bringing law and order to the increasingly violent Chesapeake Bay. There would be no warm welcome for Captain Davidson from the watermen already out fishing the bay's icy waters; he was a man hated by many of the oystermen, and he knew that some of them even wanted him dead. A United States Naval Academy graduate and a veteran of the Civil War, Davidson was a man with a reputation for bravery and steadfastness. His impatience grew as he waited for the installation of the twelve-pound Dahlgren cannon, a deadly weapon acquired from a former Confederate ship, on the bow of the bay schooner *Mary Compton*.[72] This new gun could likely sink any boat that he chose to fire upon, but in case he needed to shoot more quickly and accurately, he also carried a firearm on his belt and stowed several other guns below in the boat's cabin.

When it came time to slow the mad oyster rush, it did not go smoothly. The Annapolis legislature was the first to sound the alarm, in 1820, after watching the flood of New England dredgers fishing the Chesapeake Bay. The first conservation law was passed with the grim warning that "well grounded apprehensions are entertained of the utter extinction of oysters in the state."[73] But the significant political power of the wealthy oyster merchants easily drowned out the voices calling for more protection of the dwindling Chesapeake oyster beds.

Dredgers were blamed for most of the damage. Their efficient scoops accelerated the race to keep up with what was becoming an international demand for the delicacy. There was an early law that outlawed dredgers altogether, but that was dropped in favor of limiting them to fishing the deeper parts of the bay, and only under sail, no steam engines allowed. The dredgers protested the new restrictions, but this time Annapolis held its ground. If the lawmakers had anything to say about it, the bay's oyster population was not going to be eliminated.

Many watermen ignored all of the new guidelines, and the bay was overrun with poachers. Tongers against dredgers, good captains versus bad, Maryland's waterman against Virginia's—differences began to be settled with loaded guns. Before they overharvested one another into extinction, Annapolis created the Maryland Oyster Police Force in 1868 to enforce the laws on the water.

Meanwhile, harvested oysters were getting smaller. Without enough time to mature, the size of the individual oysters decreased each season, and a culling or size law was passed in 1872 that made it illegal to harvest an oyster smaller than two and a half inches. A dozen new oyster inspectors were hired to enforce the law in an effort to give young oysters, called spat, a chance to grow.[74] Other laws included daily bushel limits and firm dates to limit the

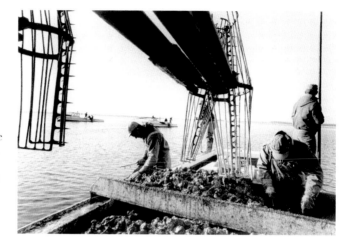

Tongers use the culling hammer to break apart the smaller piles of oysters and measure each oyster for size. Notice the tonger in back standing on the gunwale. Circa 1950. *Courtesy of the Chesapeake Bay Maritime Museum.*

official oyster season. It was a race between supplying a relentless international demand for the delicacy and the rapidly decreasing supply in the bay.

In spite of the new laws, a separate police force and a dozen new inspectors, chaos on the water prevailed. There was simply too much money to be made from oystering. The 1884 Maryland Oyster Commission weighed in with an ominous forecast, stating that "the results of our examination fully justify the worst forebodings...The oyster property of the state is in imminent danger of complete destruction."

Law-abiding Annapolis watermen like Eastport's Captain S.B.B. Gladding could see firsthand the diminishing returns for difficult days worked on the water. He operated within the laws, which included not dredging on Sundays, at night or in the shallow water reserved for tongers, and his reward was that it took twice as long to harvest the same amount of oysters as the poachers.[75] It was time to take action, and Captain Gladding set out to organize local watermen and take their expertise up the hill to the state legislature. It wasn't going to be easy. The two were disparate groups—educated, erudite lawmakers and the coarse men of the water whose educations began, and would likely end, on the bay. The fight wasn't just about the oyster, Captain Gladding argued. It was also about the money. He wanted watermen to be compensated for the loss of revenue that would come with limits on oystering, as reported in the *Maryland Gazette* in March 1896:

March 3, 1896—Capt S.B.B. Gladding of Eastport addresses a public letter to fellow watermen in the area—asking for support as he goes to the state legislature urging the passage of an oyster law that would prohibit the fishing of undersized and young oysters "but that there must be revenue

to pay for such protection" and calls for a 1-cent tax on each bushel. "Therefore, gentlemen and oystermen, the opportunity, in my judgment offers itself. Now is the time, and if you come here in a delegation…the committee has promised me to hear us."[76]

A follow-up article in the *Maryland Gazette* three days later shows that Gladding's call to arms was answered by the watermen:

Captain Gladding had a large delegation of oystermen in support of his proposition for a new oyster law before the committee on the Chesapeake Bay and its tributaries yesterday. The tax would raise the necessary revenue to maintain the oyster navy and place a large balance in the treasury to possibly reduce the real and personal property taxes.

The Annapolis oystermen continued to organize and created a number of different watermen's associations over the years, depending on the

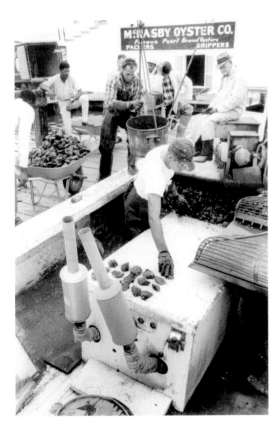

The waterman keeps track of the number of bushels unloaded with oysters lined up on the engine box, while Mr. McNasby keeps his own count on his clipboard. 1970. *Photo by Robert DeGast, courtesy of Chesapeake Bay Maritime Museum.*

different crises or problems they faced. In 1904, the Eastport & Annapolis Oystermen's Protection Association was formed, the forerunner to today's Maryland Watermen Association, which was incorporated in 1973.[77]

In addition to the watermen's war with nature and legislation, two additional battles raged. The competition between Maryland and Virginia watermen escalated in the early 1870s as the two groups trespassed into each other's fishing areas. Maryland watermen were also at war with one another. Hundreds of dredgers were openly breaking the law, pulling up oysters from the shallow waters reserved for tongers. The dredgers' reputation sank like a stone, and the word "dredger" became synonymous with outlaw. Violent attacks continued from all sides, and the sound of gunfire increased across the Chesapeake Bay. A reporter for *Harper's* magazine described oyster dredging in an 1884 article: "Dredging in Maryland is simply a general scramble, carried on in 700 boats, manned by 5,600 daring and unscrupulous men, who regard neither the laws of God or man."[78]

A story in the *Baltimore Sun* reported that something new was floating in the Chesapeake's rivers and creeks—the bloated bodies of dead oystermen.[79] The violent clash between the law-abiding, the lawless and the law would last for decades and would be remembered as one of the most violent times in the history of the Chesapeake Bay.

ANNAPOLIS WATER LAWMEN—THE MARYLAND OYSTER NAVY

When Captain Hunter Davidson initially accepted the position of commander of Maryland's Oyster Navy, also known as the Oyster Police, he did not realize that so many people would want him dead, particularly over something as small and benign as an oyster.[80] But Davidson remained committed to restoring order, despite the danger of his new position.

Just after midnight on a frigid January night in 1871, near St. Michael's, a small boat filled with poachers eased its way through the ice to Davidson's steamer, the *Liela*. Sneaking on board, the outlaws quickly knocked out the man standing guard with an oyster-culling hammer and charged Captain Davidson's cabin. Their struggle to open his locked cabin door woke Davidson, who jumped out of bed, grabbed his Colt revolver and quickly fired two shots through the door. The poachers scrambled back to their boat and rowed for their lives, while Davidson went after them, shooting over their heads. The men stopped long enough for Davidson's men to arrest them and bring them back to the *Liela* in shackles.[81]

Under Davidson's leadership, the Oyster Navy arrested more than 130 men and brought in over $7,000 in fines for illegal dredging.[82] Before anyone could declare success, the next season brought even more intense fighting between the watermen, to the point that the Oyster Navy posted armed schooners at the mouths of several rivers. Davidson joined the few voices alerting Annapolis lawmakers that the oyster population was being recklessly depleted, but his warnings fell on deaf ears. Politics prevailed, and lawmakers sided with the large number of local oystermen to gain their votes. Inevitably, political appointees were named to the force, and Davidson was helpless to stop it. With his power diminished and a bleak future as commander, Hunter Davidson quit in disgust. The new officers proved ineffective, as they were more interested in a paycheck than in getting shot.[83]

New blood and political clout brought back a strong Maryland Oyster Navy in the 1880s, the years of record-breaking oyster harvests. Its new commander, James Waddell, had three steamers and ten schooners in his flotilla, all heavily armed. Waddell was not someone to trifle with—tall, handsome and a veteran of both the Mexican and Civil Wars, he was also a graduate of and former teacher at the Naval Academy. During the Civil War, he served with distinction in the Confederate navy as the lieutenant commanding the schooner *Shenandoah*, capturing thirty-eight vessels, decimating the Union's New England whaling fleet and inflicting damages of over $1.3 million.[84] His military expertise would be put to good use with the difficult and dangerous work of the Maryland Oyster Navy.

Despite his extensive military experience, Captain Waddell proved no match for the pirate poachers. The illegal dredgers had been at their trade for years, enough time to perfect their skills at illegal oyster raids. It was deviously simple. A guard in a small boat was posted outside the illegal fishing area, and once the police were spotted, the lookout raised a flag or, if at night, a light to warn the poachers that the police were coming. With a dwindling oyster population and higher demand for the shellfish, the stakes got higher. A local newspaper observed that there were two new classes of oyster poachers—those who fled at the sight of the authorities and those who stood their ground for armed combat with them.[85]

Poachers worked their dredgers farther up the bay's rivers and creeks, pushing the tongers out of the way, or worse. In March 1881, a fleet of dredgers capsized several tongers working the shallow water of the Chester River, north of Annapolis, and as usual the dredgers were heavily armed in case they had to shoot their way out. In what was a typical exchange, the police boat *Nannie Merryman*, skippered by Captain John Wilson, entered the Chester and shouted for one of the dredge boats to heave to, or stop,

and prepare to be boarded. The dredgers responded simultaneously with a barrage of gunfire. The crew on the *Merryman* swung the swivel Hotchkiss rifle and poured lead into several of the boats. Two of the illegal ships were captured and several men were arrested, but one of the owners of the boats was fined just $200 for illegal dredging.[86]

SLAVERY ON THE WATER

Dredge captains were getting desperate to find enough crew to work the icy winters. Before the combustible engine, it took four men to work the two manual windlasses—one on each side—on a dredge boat, and with more than one thousand work boats on the bay, there was a severe shortage of manpower. During the oyster boom of the 1880s, many oyster captains resorted to kidnapping, also known as crimping. Stories were rampant of unsuspecting young men being shanghaied into service on the fishing boats for days, weeks and sometimes months at a time. New immigrants just arriving to America were especially easy targets, with promises of good wages and good working conditions, but instead they became involuntary servants once the boat left the wharf.

In keeping with the rough-and-tumble world of the watermen, the captains who used the captured men were not a benevolent bunch. "We don't care where we get them," said Captain Lynn Rea of the schooner *Ella Agnes*, "whether they are drunk or sober, clothed or naked, just so they can be made to work."[87]

The prisoners were brutalized. Hauling up a dredge full of oysters onto a moving boat has been described as being "like pulling in anchor while the boat was sailing."[88] The captured men worked the backbreaking dredge from five in the morning until past sundown, with no rest and only the smallest rations of the most basic food, such as hard biscuits. There was no relief from the brutal winter waters with no real sleeping quarters or winter clothes available, as most prisoners worked in the same street clothes they were captured in. Escape was rarely an option. The captured men were locked inside the cabin for the few hours that they were allowed to sleep at night and were never allowed onshore. The one exception was when a captain wanted to get rid of someone and left him on some random shore to somehow find his way back to Annapolis or Baltimore.

Inevitably, many of the captured men suffered psychological breakdowns and physical collapse. "Oyster hand" was an excruciating infection of the hands from handling the toxic, razor-sharp shells without protection. The

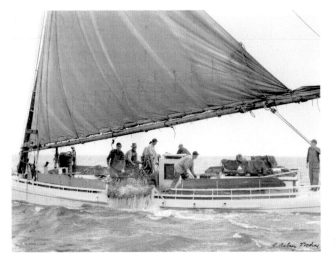

Both mechanical windlasses are bringing up dredges, one on either side. *Courtesy of A. Aubrey Bodine, 1928,* © *Jennifer B. Bodine, www.aaubreybodine.com.*

cut hands would fester, become inflamed and require hospitalization, which was not a likely option for the suffering crew.[89] A prisoner worked to "earn" back his freedom for a period of time determined, and often extended, by the boat captain. Some captive crewmen were promised a wage, but the brutal captains avoided payment by turning the ship's tiller abruptly while under sail, causing the ship's boom to fly across the deck and knock the unsuspecting man into the icy Chesapeake, where he was left to drown. This was a method of payment called "paid at the boom." As the need for crewmen increased, so did their prison terms. Several broken-down shacks filled with emaciated men were discovered on a waterfront miles south of Annapolis. The prisoners were stored there for dredge boat captains who needed the labor. The men were rescued by the Oyster Navy in 1886, but stories of cruel treatment, starvation and brutal murders continued for many years.[90]

Unbelievably, Maryland's general assembly, in 1885, refused to step in and put an end to the inhumane treatment. Wealthy oyster businessmen leaned in and told lawmakers to stay out of it. It would be five years before legislators changed their minds and passed a law that required harbor masters to maintain a registry of oyster boat crew, their time and their wages. The law also held boat captains accountable for any crew who did not return—the captains faced six months in prison. Illegal captains were as impervious to the new laws as the ones already on the books, and the abuse of sailors on the bay continued into the twentieth century, even in the face of a federal law that outlawed kidnapping in 1908.[91]

The prisoners on the water were eventually freed, not by Annapolis lawmakers or the hardworking Oyster Navy, but by the advent of the

combustible engine. In the early 1900s, an eight-horsepower gasoline engine powered the windlass to bring up the heavy metal dredges and replaced the manual labor of four men. This early technology ended almost twenty years of one of the most shameful episodes in the maritime history of the Chesapeake Bay.

OYSTER PACKERS AND SHUCKERS

While Annapolis oystermen battled arduous conditions for relatively decent wages, the Annapolis and Baltimore oyster businessmen raked in millions of dollars from processing, packing and shipping the Chesapeake oysters as far as three thousand miles overland and overseas. It was easy arithmetic—the packers paid about half of what they sold the oysters for.

Oysters were harvested from the early fall to late spring, months that contain the letter r. The myth that oysters are poisonous from May to August originated in the 1840s, when oysters were shipped in warm weather before refrigeration was available.[92] Without refrigeration, shipping oysters was part luck and part timing, since oysters spoil quickly and can be fatal when bad.

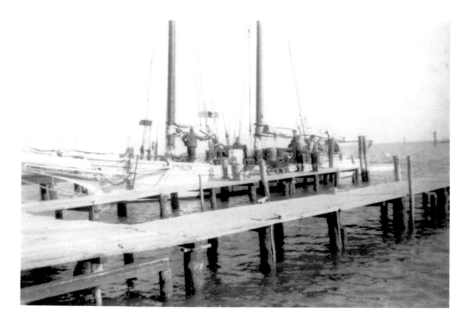

The *Anna and Helen* at McNasby Oyster Company's dock, circa 1940s. McNasby's opened in 1906 on Compromise Street at City Dock and moved to Eastport in 1918. *Courtesy of the Annapolis Maritime Museum.*

Annapolis had every interest in preserving the oyster's reputation, as seen in the following *Maryland Gazette* article, headlined "Oyster Disease," in October 1854:

> *There is at present a panic in the oyster market, in consequence of a prevalent belief that there is a disease among the oysters, which is apt to give fatal sickness to the eater of them…Annapolis is very much interested in this thing; consequently we feel called upon to defend the delicious bi-valve from the serious charge. Oysters are eaten very extensively here, but we have not heard of a single instance of sickness from eating them…and the most minute investigation has failed to expose any defect in them. All experience shows that there is nothing more healthful than your fine, fresh oyster—and it is a pity that honest dealers in the article should suffer loss from an unfounded accusation against their merchandise. Fast young men have always been ready to declare it was "the oysters made them sick last night." But…there was always, in such cases, a well grounded suspicion that "something" was taken with the oysters.*

Before packing plants, watermen sold their oysters directly to "buy boat" schooners out in the bay. The buy boat captains, many of them from New England or New York, would let the watermen know that they were open for business by hoisting a basket to the top of their ships' masts. Selling to a buy boat meant that the watermen could keep oystering instead of taking the time to come in to sell their catch on land. The downside to selling to a buy boat was the profit margin—a waterman received a better price selling directly to the packing companies.

During the peak years at the turn of the twentieth century, there were ten oyster-packing companies in Annapolis, including the Colored Union Oyster Packing Company on City Dock for black watermen and oyster merchants.[93] As a footnote to history, black oyster merchants had been operating in Annapolis since just after the War of 1812, when one of three black-owned businesses in the city was an oyster house in the center of town run by John Smith Jr. In the early 1820s, Charles Hanson, a recently freed slave, opened his own oyster house as well.[94] As busy as Annapolis oyster packers were, there were more and much larger packinghouses in Baltimore because of the new Baltimore and Ohio Railroad, which shortened cross-country delivery considerably.

Until 1909, Annapolis oyster packers shipped shucked oysters in hardwood barrels and kept them fresh with a quick process. After hot, melted paraffin was ladled into each barrel and sloshed around until the inside was thickly coated, a packer measured oysters into each barrel and then dropped a big chunk of ice on top. A barrel head was laid on top and secured by the final steel hoop

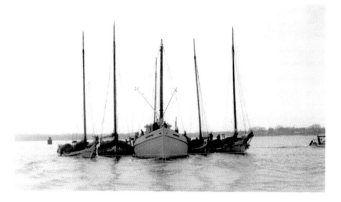

A buy boat in action on the bay. At the left is a bushel measure being lowered into the skipjack. Circa 1960. *Photo by Robert DeGast, courtesy of Chesapeake Bay Maritime Museum.*

hammered into place at the top. The shipping destination was written on a ticket and tacked to the barrel head. Competition between oyster packers was fierce, and unless careful, the competition could steal customers by copying down the customers' information on the tickets. In 1910, the country's new Food and Drug Administration (FDA) stepped in and required the shipped oysters to be packed in metal cans using a new steam-canning process and then surrounded by cracked ice in large wooden containers, which allowed the oysters to travel longer distances. The new FDA-approved measures were expensive, and the added cost put some oyster packers out of business.[95]

In addition to the canned shucked oysters, the other two categories for sale were oysters on the half shell and oysters still in the shell, unopened. Discarded oyster shells were seen everywhere in Annapolis. Eastport's roads were paved with oyster shells, making them a "splendid drive," as highlighted in the *Evening Capital* in 1887. McNasby's, a local packing company, also provided crushed shells to the Naval Academy for use under new buildings.[96] The discovery that empty shells can help spat grow put an end to oyster shells on roads, and Maryland fishery officials were tasked in 1886 with buying available shells from the plants and putting them back into the Chesapeake Bay "for the propagation of oysters."[97]

Oyster plants were only as successful as their shuckers, the men and women who deftly removed the slippery oyster from the razor-sharp shells, sometimes in less than five seconds an oyster. Many of the shuckers were women and/or African Americans, a trend that continues today in the few oyster packinghouses that remain. Working conditions for the early shuckers were miserable. The season for shucking oysters was the same as catching them—the icy, cold winters of the Chesapeake Bay, with the same biting wind that embattled the watermen seeping into the barely heated packinghouses. Shuckers stood shoulder to shoulder at a long table, or more often in narrow stalls just wide

A shucker received a metal token for every gallon filled, as seen on the counter to the right. McNasby's "Pearl Oysters" were named after his wife. Circa 1918. *Courtesy of the Chesapeake Bay Maritime Museum.*

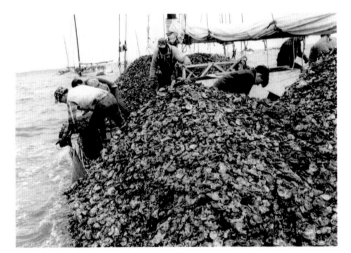

Oystermen were paid in the off-season to take empty oyster shells from the packinghouses and reseed the bay, as well as its rivers and creeks. Circa 1960s. *Photo by Robert DeGast, courtesy of Chesapeake Bay Maritime Museum.*

enough for the shucker (or sometimes on small platforms) for about twelve hours or more a day, a few inches above the slippery muck of shells and oyster water. Men with wheelbarrows or large buckets filled with fresh oysters went up and down the rows of shuckers to dump piles of new oysters to be shucked and remove the spent shells. In one motion, the shuckers worked with an oyster knife in one hand and the oyster in the other, dropping the cold oyster into a gallon bucket. A record was kept of the gallons filled, and the shuckers were paid by the gallon.[98] In 1918, McNasby's employed thirty-two shuckers with wages that averaged twenty-eight dollars a week per shucker.

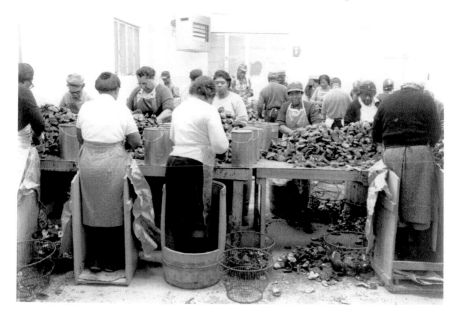

An experienced shucker could open and empty an oyster in less than five seconds. Bonuses were given for every gallon filled over the expected number. Circa 1960. *Photo by Robert DeGast, courtesy of Chesapeake Bay Maritime Museum.*

By the early part of the twentieth century, the oyster madness had slowed. There were more oystermen than ever, looking for fewer available oysters. The *Annapolis Advertiser* ran the following item in its March 4, 1918 edition that best illustrates the slowdown:

> *Due to the glut existing at present in the oyster market, local shippers have received word from the New York, Philadelphia and Baltimore wholesalers to make no more shipments until further orders are received. This glut is due to the sudden thaw releasing the oystermen after a long tie-up. They suddenly swarmed upon the oyster beds, making large catches and a flooded market ensued. As a result there is no sale for oysters in Annapolis today. No sales have been made today to the "buy" boats, all of which are now loaded.*

The abundance of oysters at market did not tell the true story of the plummeting number of Chesapeake Bay oysters, a shortage that only intensified the competition between watermen. The Maryland Oyster Navy finally gained control of the poachers with an increase of weapons and a larger fleet, effectively ending the deadly gun battles on the bay. The oyster harvest slowdown after 1918 continued a steady decline, and despite stabilizing somewhat in the 1970s, the decline continues today.

CRABBING TAKES HOLD

Compared to oysters, crabbing has always been considered the less difficult and less dangerous job for watermen. It has a liberal fishing season that wraps around the more comfortable months of May through September but can go as late as December, despite fewer available crabs in the winter. Unlike the oystermen, who often wage battle with the choppy Chesapeake Bay, crabbers work in the shallower, calmer waters of the bay's creeks and rivers. With or without a boat, a crabber can work solo and doesn't need any heavy equipment. From the beginning, for reasons that scientists cannot fully explain, the crab population has fluctuated wildly from season to season, so a crabber cannot always depend on a steady income. For example, crab totals for the 1929 season were sixty-eight million pounds, and three years later thirty-nine million pounds were brought in, only to peak in 1966 at ninety-seven million.[99]

During much of the nineteenth century, the status of commercial crabbing was shaky. Catching crabs was considered a leisure activity, or really just a way of acquiring something else to eat.[100] By the early 1870s, crabmeat started to catch on, and a handful of Maryland fishermen began selling crabs commercially. It took 250 years, but the crab was no longer the scorned refuse of colonial Annapolis; instead, it was all the rage. It was so popular, in fact, that by 1927 Maryland had passed a conservation law to protect the crabs from disappearing. Even with the law enforced, two years later came the 1929 bountiful harvest of sixty-eight million.

Compared to oystering, commercial crabbing in the early twentieth century was considered a much smaller but more respectable industry, and crabbers enjoyed a much better reputation than their nefarious oyster dredger colleagues. However, when it came to shipping, crabs were far more fragile than oysters. Oysters were easily shipped across the Atlantic, while crabs, particularly soft-shell crabs called "peelers," were too perishable for anything but the most local commerce until refrigeration was available.

Shipping soft-shell crabs proved to be an even bigger problem than catching them. Direct contact with ice kills crabs. Faced with no alternative, boxes of up to five thousand crabs were shipped to Baltimore by steamboat, and the crabs arrived crushed, emitting the overwhelming stench of rapidly decaying shellfish. The shippers then tried packing the soft crabs on crushed ice covered with cheesecloth—this time, they had better luck. The crabs survived four to five days, and with the extended shelf life, their popularity soared. They appeared on hotel menus and in fine restaurants up and down the East Coast.[101] To ease the difficulty of finding the molting peelers,

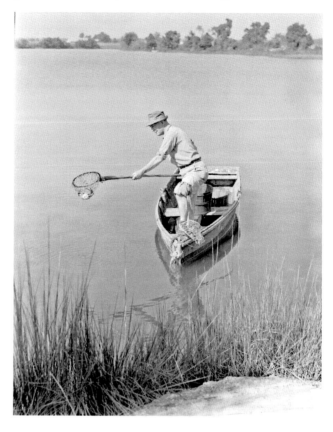

A crabber catching soft-shell crabs, also called peelers. Peelers can be difficult to find as they hide in tall grasses during the molting process. Circa 1960. *Courtesy of Charles E. Emery.*

crabbers developed shedding floats, which were tethered boxes built to protect crabs from their natural predators.

Around the 1930s, crabbing caught on as a summer pastime synonymous with the Chesapeake Bay, and recreational crabbing became an integral part of the Annapolis economy. Every summer, particularly after World War II, hundreds of rowboats were scattered over Annapolis creeks and rivers, with baited trot lines hanging off the boats. Young or old, rich or poor, everyone went crabbing in Annapolis, even if just from the end of a dock, dangling a chicken neck tied to a piece of string in the water.

In nineteenth-century Annapolis, crabs were hawked up and down the downtown streets by vendors selling the crabs door to door. A dozen large-sized soft crabs cost fifty cents, and steamed hard crabs cost just twelve cents a dozen.[102] The majority of the local crab-picking plants, called crab houses, were on either side of City Dock, convenient to the crabbers and the Fish Market.

The Fish Market at City Dock had one-room restaurants on each end called cook shops or eating rooms that featured freshly made crab dishes,

A postcard of the Fish Market dated 1904. The open stalls allowed a waterman to sell his fresh catch directly to merchants without leaving his boat. The small shacks on the end are cookhouses, where fresh crab cakes were sold. *Courtesy of the Chesapeake Bay Maritime Museum.*

such as crab cakes and deviled crab.[103] Outside the Fish Market, there were also a few small shacks where enterprising crab pickers made their own crab dishes to sell with crab they purchased from the nearby crab houses. A dozen fresh crab cakes cost about fifty cents. Competition was tough between cook shops, so there was a lot of crabmeat in each cake. Given today's environs, it's difficult to imagine that all that work of picking the meat and cooking it over a hot stove in a small shack in the summer heat was worth the fifty cents.[104] While commercial crabbers were generally men, the tedious and difficult job of extracting meat from underneath the crabs' sharp shells, as well as cooking in the hot cookhouses, fell to women. Baiting trot lines with salt eel at the end of the day in preparation for the next day's fishing often fell to the crabbers' wives.

Herbert "Cap'n Herbie" Sadler was born into an Annapolis waterman family in 1902 and started working for a local seafood vendor cleaning fish when he was twelve years old. Fourteen years later, newly married with two boats for fishing, Herbie opened his own seafood business in Eastport, featuring crabs that he caught around Annapolis.[105] An institution for over forty years, Sadler's Seafood on Spa Creek was the place to get crabs, by car, by boat or on foot.

Crabs, particularly the popular peeler crab, have been a thriving Maryland industry for over a century, and the Chesapeake Bay remains the number one provider, over any other body of water, including any ocean, of crabs to

consumers.[106] Sadler's Seafood closed its doors in 1975, but on the outskirts of Annapolis, crabs in the rough are still served at a few restaurants and crab houses, such as Jimmy Cantler's Riverside Inn on quiet Mill Creek, run by a third-generation waterman.

THE OTHER BAY BOUNTY—FISH AND CLAMS

For the fish that need a healthy mix of salt water to live and fresh water to spawn and grow, the Chesapeake Bay is the perfect environment. The most prized fish for sport and commercial fishermen is the striped bass, or rockfish as it is known locally. The name likely came from its original species classification, *Roccus saxatilis.* Although scientists corrected the genus designation to *Morone saxatilis* in the late 1960s,[107] it is fortunate that the familiar moniker did not change to moronfish. The bay is the largest nursery for young rockfish and plays host to 70 to 90 percent of the entire Atlantic striped bass population. The Chesapeake Bay record for Maryland's state fish was set in 1995, just south of Annapolis, with the caught fish weighing an eye-popping 67.5 pounds.[108] That is especially impressive considering the rockfish is known for its fighting ability. A decline in the rockfish population in 1985 caused by overfishing and pollution forced Maryland to impose a moratorium on harvesting the species for four years. The ban was successful, and the rockfish population thrives today.[109]

The unattractive and inedible menhaden is the least appreciated fish of the bay, but it has developed into a million-dollar industry—it is processed into oil, animal feed or as a soluble for cosmetics, linoleum and steel. Critical to the ecology of the Chesapeake Bay and Atlantic Ocean, the pudgy, pale, foot-long menhaden is a food link between plankton, which it eats, and its own predators, such as striped bass, bluefish, tuna and sharks. Menhaden was used primarily as bait for crabbers in Annapolis until its lofty position was usurped by the chicken neck. Even its nickname lacks dignity—it is called "bugmouth" for the large crustacean parasite that lives contently in the menhaden's toothless mouth.[110]

Around 1800, in what sounds like modern irony, more than 700 bushels of soft-shell clams were exported annually to New England, which in turn shipped its oysters to Maryland. Once a thriving Maryland industry, the commercial clam harvests from the 1950s through 1971 produced an annual harvest of nearly 500,000 bushels of clams. Locally, the best place to harvest soft-shell clams was once in the sand and mud off Greenbury Point, but Tropical Storm Agnes virtually eliminated Annapolis clams in 1972, causing

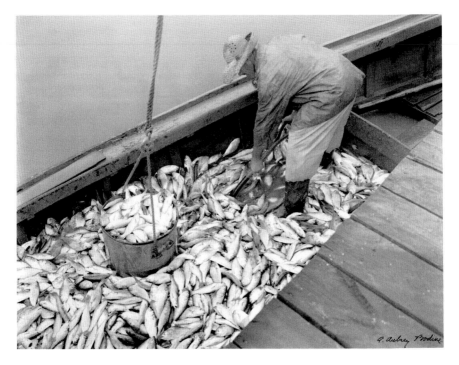

The most unattractive and inedible fish, the menhaden is also among the most lucrative of catch. It is sold as fertilizer and as a soluble. *Courtesy of A. Aubrey Bodine, © Jennifer B. Bodine, www.aaubreybodine.com.*

severe damage to the shallow waters. Clam harvests never fully recovered, and after a peak of 680,000 bushels in 1965, annual harvests plummeted to fewer than 1,000 per year in 2004.[111]

The number of Maryland watermen who still work the water today is down to about three hundred from the more than seven thousand registered in Annapolis one hundred years ago.[112] Of the few Maryland seafood processors left, none remain in Annapolis, and the once thriving McNasby's Oyster Company is now the site of the Annapolis Maritime Museum, dedicated to educating people about Annapolis's rich maritime history. The seafood that the earliest Annapolis settlers ate as a last resort, except the protected terrapin, continues as a multimillion-dollar industry for Maryland and is one of two main attractions that bring three million tourists to Annapolis every year. Following a similar path as its seafood, boating in Annapolis began as a necessity for survival and growth for the seventeenth-century settlers and evolved over time into the city's primary form of commerce and a national pastime.

WATER ROADS TO
PLEASURE BOATING

I have often heard old sea-captains, who have traversed almost every known sea, lake, bay, and river in the world, speak in the most exalted terms of the noble Chesapeake. As a bay it has no equal, not even in that of Naples, all things considered. I know of no more delightful trip, especially in the summer season. A scene on the Chesapeake...is truly inspiring alike to the poet and painter, as well as invigorating to health and renovating to the finer feelings of sentimentality and romance.[113]

The gushy description above was written in the mid-1800s by an anonymous traveler aboard the steamer *Georgia* plying the bay. It is a description that may seem exaggerated to anyone not familiar with being on the Chesapeake on a beautiful day.

Today, the Chesapeake Bay enjoys a reputation as one of the best bodies of water for recreational boating, but for over three hundred years it was primarily a working waterway; a way to cut miles and hours off a trip overland, the fastest route for shipping and, of course, the source of the greatest variety of seafood to harvest. With the decline of the oyster beds and the introduction of the internal combustion engine, so went many of the picturesque working sailboats, Chesapeake log canoes, bugeyes and skipjacks. Of the more than one thousand skipjacks that worked the waters in the late 1800s, only seventy-five remained in 1949. For many years, these boats have evoked a romantic ideal for Marylanders, and the brutally hard life of a waterman is all but forgotten when one of the few remaining skipjacks races into Annapolis Harbor with full sails, driven by a northwester howling down the Severn River.[114]

The development of the original long, thin, swift-sailing log canoe from the width of a single log grew to two, three and eventually five logs and was considered one of the most daring sailing designs ever seen in North America. "They can out-sail every vessel on these waters that is not propelled by steam,"

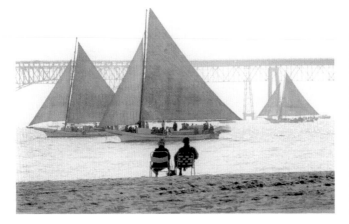

Chesapeake Appreciation Days began in 1965 and featured skipjack races in late October, on the eve of dredge season. This picture was taken from Sandy Point. *Photo by Robert DeGast, courtesy of Chesapeake Bay Maritime Museum.*

wrote a visiting minister to the bay.[115] By the early 1920s and '30s, changes were afoot, with organized races for the swift log canoe work boats, while some of the oyster workhorses, the bugeyes, were converted into yachts by recreational sailors of financial means—which was a lot of boat for the money.[116]

People who know Annapolis waters and its traditions will say that informal races have been around since the late colonial era, when work boats raced one another to the good fishing grounds before dawn and then back home at the end of the day.[117] The idea that racing sailboats in Annapolis would one day become widely popular and financially sustainable would have seemed far-fetched to the early Annapolis watermen who risked their lives working the often choppy and unpredictable Chesapeake. In those days, just about everyone had a boat in Annapolis, but it was generally a work boat. And on that rare day off when the only way for a family to beat the Annapolis summer heat was to be out on the water, the work boat became a pleasure boat.

After World War II, there was a confluence of a great number of work boats and a growing number of recreational boats, which made Annapolis boatyards busier than in any other time of peace. The Tidewater Chesapeake Association released a survey on Annapolis's boating industry phenomenon in May 1949, which put a $3 million estimate on the city's boating industry revenue that covered seventeen boatyards along Spa Creek and Back Creek.[118]

The survey totaled $950,000 in gross income. The remaining $2 million-plus was calculated by noting that with every dollar spent at the boatyards, two dollars were spent away from the dock in town. Annapolis had its newest and latest water trade—boating, sailing and the people who enjoyed them. However, long before the big money of recreational boating, the bay was used principally for transportation, crucial to the city of Annapolis and the other colonies that one day would become their own nation.

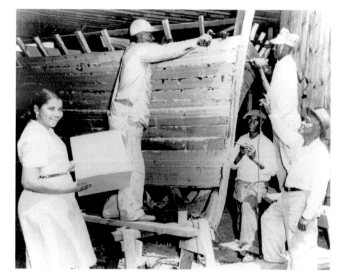

Thompson's was a successful boatyard on Back Creek in Eastport and one of the few owned by an African American. Founder Charles Thompson is at far right. 1951. *Courtesy of the Annapolis Maritime Museum.*

ANNAPOLIS FERRIES—TRANSPORTATION TO EXCURSIONS

To travel through colonial Maryland and the other Chesapeake colonies, one had to choose between traversing many miles overland or ferrying over a river or creek. Beginning as early as the late 1600s, Annapolis was a popular ferry depot. The earliest ferries, called packets, were traditional Chesapeake log canoes powered by men with poles or paddles. By the 1700s, ferry captains used oars and, still later, sail. Beamier or wider boats were built to carry more passengers, a few horses and a wagon. For longer distances across the bay, larger sail vessels, such as schooners and sloops, were used as ferries.[119] Ferries to the Eastern Shore were especially popular, cutting the nine- to ten-hour trip overland to places such as Delaware or Philadelphia in half. President George Washington took the ferry shortcut from Rock Hall on the Eastern Shore to Annapolis in March 1791, but his trip did not go according to plan.

It was cold and dark that evening, and a trip that should have taken just five hours was into its tenth hour, with still no sight of Annapolis. The ferry had left the Eastern Shore at 3:00 p.m. in calm water, but light winds had strengthened to gale force before the boat could reach the mouth of the Severn River. Badly off-course because of the dark and stormy conditions, the ferry ran aground on Greenbury Point. The crew freed the vessel from the muck, only to run aground again, this time off Horn Point, modern-day Eastport. The boat would not budge this time and remained hung up on the shoals, or shallows, into the night.

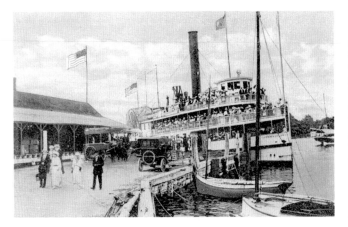

An early postcard of the *Emma Giles*, which made regular trips between Baltimore and Annapolis. For thirty-five cents, a passenger could take the whole sixteen-hour round trip or any part of it. *Courtesy of the Chesapeake Bay Maritime Museum.*

At some point during the ordeal, President Washington went below to get some sleep, and as he later described to a friend, "[I] lain all night in my great coat and boots, in a berth not long enough for me by my head, and much cramped."[120] While our country's first president tossed and turned below, the ferry captain sent a distress signal. Help came the next morning, and the packet was pulled off the shoals. General Washington continued on to Washington, D.C., to take care of the business of the new nation.

Competition between ferries was tough, and many ferry owners advertised special fares for the more popular routes and added new routes to places such as Upper Marlboro and towns on the Potomac River.[121] Despite the fact that ferries were sturdier than their Chesapeake log canoe predecessors, capsizing and drowning were still standard risks for ferry passengers.

Many of Annapolis's earliest ferry captains were eighteenth-century versions of U.S. Coast Guardsmen. The *Maryland Gazette* reported in May 1755: "On Monday last, by the violence of the wind, the Baltimore packet overset at Horn's Point: The people, three in number, were happily saved by the assistance of Mr. Middleton's boat, which he sent out to their relief."

Samuel Middleton had a fleet of ferries in downtown Annapolis, one of them was described in the *Maryland Gazette* as a "neat sailing boat, 20 feet…neatly painted green."[122] Middleton was also the owner of Middleton's Tavern, which occupied the same building as today's Middleton's Tavern, still in the center of all the action at City Dock.[123] One Annapolis ferry owner, James Hutchinson, had trouble finding good help and, in desperation, took out an ad in the local paper "to warn all persons against supplying his ferry hands with liquor" or he will "sell [his] ferry." Hutchinson also had a towboat, which he reported lost eighteen months later.[124]

Steamboats began to replace the Annapolis ferry packets in 1813. The first was the massive 130-foot long, 22-foot-beam *Chesapeake*. Steam quickly replaced sail for transporting passengers, mail and perishable goods. Sail remained competitive for more than a century, carrying large cargoes of grain, lumber, fertilizer and coal.[125] With greater passenger capacity, steamboat travel became increasingly more popular, and traffic in and out of the port of Annapolis grew. They were especially crowded on nice days or when a passenger wanted to avoid the overland trip by stagecoach, which often meant helping push it out of deep mud when it became stuck on the unpaved roads.

Two steamships, the *Joseph E. Coffee* and the *Maryland*, made four stops a day in Annapolis, usually on round-trip routes from Baltimore to the Eastern Shore. And the more popular 187-foot-long side-wheel steamer *Emma Giles* made two round trips a week between Baltimore and Annapolis, with stops at Galesville and the West and South Rivers.[126] The massive steamers moved ten miles per hour—an awesome rate of speed at the time. The *Emma Giles*, for instance, left Baltimore at 7:00 a.m. and returned at 11:00 p.m. For thirty-five cents, a passenger could take the whole sixteen-hour trip or any part of it.[127]

In the mid-1800s, prosperity contributed to an increase in leisure time. Almost overnight, people from Annapolis and towns nearby began to discover relaxation and pleasure on the water. The ferries were especially crowded during the oppressively hot Annapolis summers. Passengers boarded the ferries at the city's two wharves, at the ends of Prince George and King George Streets. The excursions were generally well-ordered, albeit crowded, events with families dressed in their best summer linens and straw

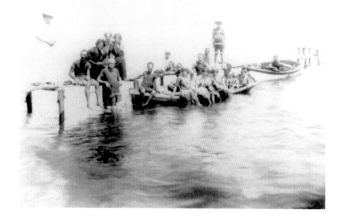

Early residents of the African American summer resort Highland Beach and their guests pose on their community pier. Circa 1900s. *Courtesy of the Highland Beach Community Association.*

hats, carrying parasols and picnic baskets. Things were fairly uneventful for the first ten years or so, until July 5, 1847, when a riot ensued, culminating in what is referred to as the "Battle of Annapolis." The newspaper *Chronicles of Baltimore* printed the following account the next day:

> *On the fifth of July an alarming riot took place between the citizens of Annapolis and a portion of the passengers of the steamer,* Jewess. *The steamer left Baltimore on an excursion to St. Michaels; when about twenty miles down the river it was found that in consequence of the crowded state of the boat, it would be too dangerous to cross the Bay to the Eastern shore* [and was] *run into Annapolis. After a short time a fight was started on the wharf between some citizens of the town and some of the young men who were on the boat. In a few minutes the fight became general, and for the time assumed a fearful character. Stones, brick, and missls* [sic] *in abundance were thrown indiscriminately upon the boat, striking ladies and children as well as others.* [128]

Things went from bad to worse on that hot summer day at the Annapolis wharf. The captain of the *Jewess*, Captain Sutton, was unable to convince the 700 passengers that 150 of them needed to disembark so that the ferry could safely travel to St. Michael's. But staying in Annapolis was not an option for the incredulous passengers. Some of the passengers secured rifles and fired on the Annapolis crowd, many of whom were engaged in fistfights with other passengers. Five were injured by the gunfire. A riot ensued, and the ferry captain decided that it was time to leave the scene, despite some passengers being left behind. Pulling away from the dock too quickly, the *Jewess* became wedged between the two wharves.

The crowd grew as word of the riot on the wharf spread quickly through town. A small group from the mêlée ran to maneuver the state's cannon into position to fire on the *Jewess*, while other rioters returned with loaded guns. Colonel George P. Kane, a resident of downtown Annapolis, placed himself in front of the cannon and told his neighbors that if they were going to use it, they would first have to blow him to bits. While local law enforcement officers tried to regain control, the *Jewess* broke free and sailed away. Unbelievably, no charges were filed on either side. It is unlikely that the ferry passengers expected those kinds of fireworks on that Fourth of July weekend excursion.

In a tradition that continues today, one of the most popular summer day trips was exploring the Eastern Shore. To answer the growing need, in 1916 Maryland's general assembly authorized an official ferry system

between Annapolis and the Eastern Shore, with the Eastern Shore ferry terminal located in Claiborne, a town between St. Michael's and Tilghman Island. Three years later, the Claiborne–Annapolis Ferry, Inc. bought its first ferryboat, a propeller steamer, the *Governor Emerson C. Harrington*, named after the sitting governor. The new steamer carried passengers, freight and as many as forty buggies, wagons and cars. Hundreds from Annapolis and the surrounding area discovered the remote and expansive Eastern Shore as recreational travel became affordable for laborers, new immigrants and other families of modest means.

More steamers were added to accommodate the booming tourism business of trips to the Eastern Shore, including the 201-foot *Majestic*. Governor Harrington became the company's new president following his term as governor, and his first order of business was to replace the side-loading steamer with double-end ferries for quicker loading and unloading.[129] To alleviate Annapolis's growing downtown congestion, the two ferry terminals were replaced with one larger station, built in 1943 at Sandy Point, about twelve miles east of Annapolis. But its popularity and effectiveness would end abruptly in less than 10 years. The new Bay Bridge permanently connected Annapolis to the Eastern Shore in 1952, ending 150 years of dependence on water transportation between the eastern and western sides of Maryland.

"The Sailing Capital"

The Chesapeake Bay is widely known as a sailor's paradise, with 4,480 square miles of boating and fishing enjoyment, but it is still small enough for a boater to quickly duck into a harbor or gunk hole when the weather turns bad. The sandy and muddy bottom is more forgiving than the rocks of New England, and the bay's shipping channel is the width of just two freighters, providing plenty of room for everyone. Appealing to even the novice boater, the bay provides seven solid months of sailing, with Labor Day as the unofficial kickoff for its best sailing season—the fall.

During the hot summer months, Chesapeake sailors learn to keep a watchful eye on the horizon for "Chesapeake dusters"—squalls that hit hard and with a sudden intensity, usually in the late afternoons.

The pattern is predictable. While sailing along in a nice breeze, a sudden hot humidity will descend and the breeze disappears. Off to the west-northwest, the sky has a distinct copper-colored glow followed by a line of black clouds advancing over the bay. Soft, fluffy gray clouds develop, and a sudden chill drops minutes before the wind hits. Suddenly, short, steep waves

build up, accompanied by a stinging torrential rain. Many sit out the fifteen-to twenty-minute storm while others head for the nearest shelter. Either way, the grand finale makes it almost worth it—a red, blazing sky accompanied by a cool breeze as the sun begins to set.[130]

Molly Winans, editor of *SpinSheet*, the popular, free, monthly magazine dedicated to sailing on the Chesapeake, warns against using the word "yacht" when speaking of sailing in Annapolis. "Yachting is Newport," said Winans. "Yachting implies something big; one-hundred-foot yachts that draw ten to twelve feet that you don't usually see in Annapolis. The bay is perfect for sailing the popular thirty-five-foot sailboat that draws only five to six feet."

Shallow draft is important; the depth of the bay averages about twenty-one feet. Constantly shifting shoals and often treacherous navigation cause even seasoned sailors to run aground miles from shore. While traumatic to the captain, running aground outside Annapolis is considered by many a rite of passage. It is not uncommon to sail by a boat that is heeled over to one side, with captain and crew enjoying a beer on the high side as they wait for a rising tide to lift them off the shoal. Hitting bottom is not a new issue; the collector of customs in Annapolis in 1887 offered a tersely worded warning about the shifting shallows in his annual report to the U.S. engineer based in Baltimore:

> *The necessity to the commerce of Annapolis of cutting away the bars of Horn and Greenbury Points, at the entrance of our harbor, seems more urgent every year as the business of the city grows…Several vessels loaded with coal, lumber, ice, etc., have grounded therein…The liability of large vessels in entering our harbor of grounding will result in such vessels refusing to freight here, thus driving our merchants to other means of freighting, which will greatly increase the cost of such articles to be borne by the consumers. I am of the opinion that the cutting away of these bars and the deepening of our harbor are of the greatest importance not only to the commercial interests of this city, but to the shipping interests generally, and to the U.S. Naval authorities particularly.[131]*

Less than one hundred years later, the author of many well-regarded books on sailing, Richard "Jud" Henderson, recalled what happened to a fellow skipper who misjudged the depth of the Chesapeake:

> [My] *acquaintance…was uncertain as to how far inshore he could go before tacking out. His sharp-eyed crew observed a pair of swimmers with their shoulder tops just clear of the water, so he suggested going in a bit closer. They had assumed the swimmers were standing on the bottom, but*

AYY boatyard workers in Eastport take a break to celebrate what looks to be a job well done. Circa 1939. *Courtesy of Mike F. Miron.*

unfortunately they had been sitting on it. When they suddenly stood up, it became painfully apparent that the Star was clear of the bottom only because she was well-heeled. The skipper slammed her over, but it was too late; they were hard aground.[132]

Annapolis maritime history is witness to well over three hundred years of similar groundings, some of them famous. Captain John Smith ran aground off Greenbury Point when the first settlers arrived in Annapolis in the 1600s; George Washington's ferry was hung up on the shoals outside Annapolis one cold night in the 1700s; during the War of 1812, deep-draft British warships abandoned their chase for local privateers up the bay's rivers for fear of running aground; the mighty *Constitution* was stuck in the mud no fewer than three times when leaving the Naval Academy on the eve of the Civil War; and even the professional sailors of the sleek modern racing boats of the Volvo International Ocean Race have run aground off Annapolis. For the red-faced, weekend skipper who bumps along the bottom of the bay, Winans offers the following: "Anyone who tells us they have never run aground has not sailed the Chesapeake Bay."[133]

While modern sailors rely heavily on navigational aids to help prevent them from running aground, imagine sailing into Annapolis in the late eighteenth century with only written instructions for guidance and just the wind for power. It is extraordinary to consider that 250 years ago there were no illuminated shorelines, lights, navigation aids or beacons.

Around the early 1800s, twenty-one navigation aids were installed on the Chesapeake Bay, making navigation a good deal easier. The number of aids grew to seventy-two over the next one hundred years.[134] Sandy Point Light is one of eleven lighthouses that remain in the bay, still maintained

by the U.S. Coast Guard; the other aids to navigation have been removed or are privatized.

The one navigational aid most closely associated with Annapolis sits one mile off Thomas Point, which is about six miles south of downtown. Thomas Point Light looks the same today as it did when the first light keeper lived there in 1875. The original Thomas Point Lighthouse was actually built on land and was later rebuilt out in the water after the original structure was destroyed by severe ice damage. Ice floes with huge sections of ice piled up onto the lighthouse and shore, the same type of damaging conditions that plagued winter navigation on the Chesapeake since the seventeenth-century. Thomas Point Light remains in excellent condition, thanks to the number of organizations that share responsibility for its upkeep.

Greenbury Point, the point of land across from the U.S. Naval Academy at the mouth of the Severn River, had a series of lighthouses beginning in 1849. The first was a one-and-a-half-story building with a massive lighthouse built on the point; that building was damaged by erosion. A cottage-type lighthouse followed, almost identical to Thomas Point Light, with screw-pile foundation. That cottage-style lighthouse was destroyed by a severe ice storm in 1918. Sixteen years later, an automatic light was installed on what was left of the lighthouse—a small, skeletal tower on the original foundation.[135] Local sailors referred to it as the Spider Buoy for the metal frame under the light, a distinctive silhouette on the horizon. The Spider Buoy was dismantled in 2008 and was replaced with a more standard marker secured on pilings. It continues to mark Greenbury Point's historic and much-maligned shallows and shoals.

In the 1950s, fiberglass quickly brought sailboats and motor yachts within the budget of America's middle class. Fiberglass and wooden-hulled boats were seen everywhere on the water in the early 1960s, particularly along the

This World War II seaplane was based at the Naval Air Station across the Severn River from Annapolis on Greenbury Point. Circa 1941. *Photo courtesy of the United States Naval Academy Archives.*

waterways of Annapolis. Maintenance and storage quickly became an issue, and many of the old boatyards, with available work dwindling, began storing, maintaining and winterizing their customers' boats instead of just building and repairing them. This evolution from boatyard to marina kept many waterfront boatyards from going bankrupt, particularly in Eastport. The Chesapeake Bay was no longer Annapolis's primary source of sustenance. Instead, the bay had become Annapolis's primary source of pleasure. Both boating and boatyards were to become important sources of revenue to sustain Annapolis's economy.

BOATING—NOT JUST FOR WORK ANYMORE

It is no surprise that some of the early bay work boats inspired many of the best-loved and fastest-sailing yachts built before the Second World War. The shipwrights and boat carpenters who built these vessels were motivated to create the fastest and most efficient boats possible. He who sailed the fastest while carrying the most cargo made the most money.

The proven quality of the Chesapeake log canoe design was the first to be featured in organized races in St. Michael's in 1840, and those log canoe races continue today. The beautiful and much larger designs of the bugeyes and skipjacks were targets of opportunity for conversion into yachts beginning in the 1930s.[136]

The *Richard J. Vetra* was one of those boats, a fifty-foot-long bugeye oyster boat that was rigged like a skipjack with one mast and a square stern. The *Vetra* was built in 1888 by shipwright G.N. Vetra on Deal Island, Maryland, where many of them were built, and was one of the first bugeyes to be frame built with a keel, instead of the usual multi-log construction method that

The *Richard J. Vetra* at City Dock before getting refit as a pleasure boat. Sadlers Hardware and Chandlery is in the background. 1933. *Courtesy of the Chesapeake Bay Maritime Museum.*

dates back to the Indians' single-log canoe. The owner of the *Richard J. Vetra* was longtime Annapolis waterman Captain Leland.[137]

Deep in the Depression in the winter of 1932, Captain Leland decided to sell his well-used oyster boat. He removed the dredge machinery and eighty bushels of unsold oysters off the deck, gave it a fresh coat of paint and hoped for the best. Yachting was just taking hold as a national pastime for America's East Coast elite in the early 1930s, and converting a sturdy but graceful old bugeye into a yacht was becoming an increasingly common practice in and around Annapolis.

The *Richard J. Vetra* was just what boating-enthusiast Milton Offutt had in mind for a sailing yacht. Offutt was a college professor in New York who spent every summer with his family on the Chesapeake Bay. The *Vetra* was more than twice as big as any of the other four boats in the Offutt family fleet, and she was perfect for family outings on the bay. With a beam of over fifteen feet, she had plenty of space below, and since she drew only three feet, she could sail in and out of much of the bay without running aground. Offutt paid Captain Leland $800 for his bugeye at Annapolis City Dock, and the *Vetra* was brought to an Eastport shipyard across Spa Creek for repairs. There were a couple of surprises when the ship was opened up. The ship's ballast was made up of several tombstones from Deal Island, and she had a mainmast step aft, or a place for another mast behind the existing foremast, typical of a bugeye.[138] Since her one boom was over forty-feet long, a so-called "man-killer" as it could easily knock someone into the water with a force to kill as it swept over the deck, Offutt liked the idea of a mizzenmast, and one was added. This allowed for two shorter booms instead of the gigantic skipjack-like boom the boat had originally.

The interior renovation was done by a ship's carpenter and oysterman from Annapolis named Captain Henry, who installed all the bells and whistles of a luxury sailing yacht, including four ample berths for sleeping, a large table to gather around, a spacious galley and a head, or bathroom, all painstakingly hand-crafted. Despite the renovations and innovations below deck, the ship looked much the same on the outside—a typical Chesapeake Bay craft—graceful yet modest, even in its size. Milton Offutt's daughter, Ann Offutt Boyden, recalled the joy of sailing the *Vetra* almost sixty years later:

> [The] Vetra *was not very good to windward, but when the breezes really piped up and when most other boats were running for cover, she would just be starting to sail to her full ability, a large bone in her teeth.*[139]

The *Vetra*'s new cabin is inspected at City Dock, with Eastport in the background. Notice the condition of the bulkhead closest to the *Vetra*. *Courtesy of the Chesapeake Bay Maritime Museum.*

Boyden remembered Annapolis in the 1930s, when sailing and powered work boats of every size and type crossed the bay. There were two- and three-masted schooners, skipjacks, bugeyes, the barge-like sailing rams, log canoes and various fishing, crabbing, oystering and clamming boats, all mixed in with the growing number of recreational boats.

Like most American families, the Offutts' summer fun ended in 1940 with World War II on the horizon. Offutt was a World War I veteran and offered the *Vetra* to the navy for patrols off the East Coast, with him as skipper. While seriously considered, one member of the Offutt/*Vetra* team was too old. The *Vetra* was rejected for duty because of her age and questionable durability. Offutt sailed the *Vetra* to a local shipyard for the last time before reporting for duty to serve in the U.S. Navy. The *Richard J. Vetra* was eventually sold, and her ultimate fate is not known.

Annapolis's Golden Age of Sail

In the August 1905 issue of *Rudder* magazine, editor Thomas Fleming Day had a rather dismal assessment of the state of yachting in Annapolis:

> *The Chesapeake offers many inducements to the cruiser, which only needs advertising to be taken advantage of. Such a splendid ground…the clubs around the North end of the Bay seem to be semi-dead and to be doing nothing to encourage or spread the sport.*[140]

Day was not being entirely fair, although it was true that sailing in the early twentieth century was more popular in wealthier northern cities like New York and Boston. Yachting and racing began in Annapolis likely as it

did everywhere else—two boats are sailing in the same direction or tack, and an informal race ensues. If a third boatman challenges the winner, a regatta is born. But even informal races need people to organize and judge the races and, of course, a place to revisit the event over a cold drink or two.[141]

The first organized boat club in Annapolis opened in 1886 as a rowing club called the Severn Boat Club, the forerunner to the Annapolis Yacht Club. Its only activities were canoeing and rowing, with organized sailing still another fifty years away. The club's original boathouse was little more than a two-story warehouse for the rowing shells and equipment, plus a few changing stalls for the rowers and a large floating dock.[142] The most popular boat to race at the all-male club was the four-oared rowing shell. The intra-club races grew to include races against teams from the U.S. Naval Academy and, later, other rowing clubs from Baltimore. The events drew large crowds, as Evangeline White recalled in her memoirs of living in nineteenth-century Annapolis:

There was great excitement in the club over this [first race in Baltimore], *and quite a number went from Annapolis to witness the race on the big schooner which carried the crew and the shells. Others went by railroad. It would be a real nice storybook climax if I could add that our town crew was victorious, but unfortunately that would not be the truth.*[143]

The occasional races grew into an annual regatta hosted by the boat club, considered the highlight of the season, with people lined up along the Eastport Bridge, spanning Spa Creek, to watch. In addition to the rowing races at the regatta, there was a "tub race"—men in round wooden washtubs paddling madly for the finish line.[144]

Serious sailboat racing was happening all around Annapolis in the early 1900s, but none of it was locally sponsored. The closest competitions included the races in St. Michael's, a few races sponsored by the Gibson Island Yacht Club and one or two Baltimore clubs. Around this time, the Capital Yacht Club in Washington, D.C., established a cruising station in Annapolis for its annual long-distance race from Washington. This race was not for the fainthearted. The race began in Washington, D.C., at 4:00 p.m., and the teams sailed through a dark obstacle course of fishnet stakes, unlit fishing boats and the usual shoals, currents and frequent squalls common to the Chesapeake Bay.[145] The outbreak of World War I ended the annual race, but in the interwar period, sailing in Annapolis began in earnest, with sailors discovering the joys of sailing on the Chesapeake Bay.

With pleasure boating on the rise, the Severn Boat Club outgrew its facilities, and in 1937, it became the Annapolis Yacht Club, Inc. (AYC). The

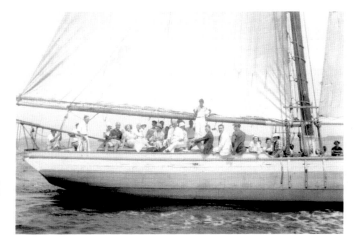

A sailing party in 1922 aboard the schooner *Australia*, which was built in 1862. *Courtesy of the Chesapeake Bay Maritime Museum.*

Flag-raising ceremonies at AYC on "Opening Day," June 16, 1958. The official opening of the summer season featured the Queen of the Chesapeake, her Court of Princesses and one accordion player. *Courtesy of the Annapolis Yacht Club.*

old shed was upgraded to a larger boathouse, with showers, a veranda and a finished second floor for entertaining. Boat storage was less of a priority for the members and their visiting wives than where to entertain, dance and dine in formal luxury.

Just a few years later, big-boat racing in Annapolis was here to stay. The AYC partnered with the United States Naval Academy and Newport's Ida Lewis Yacht Club to cosponsor the 466-mile New London–Annapolis race, which evolved in 1947 into the Newport–Annapolis Race. In May 1949, the *Maryland Gazette* called it "the most important race on the Atlantic Coast."[146] When the course was reversed ten years later, it became the Annapolis–Newport race, and it has been held every even-numbered year since that time.

The Annapolis Yacht Basin was one of the first marinas in Annapolis. A group of Annapolis businessmen bought it after the city turned down the opportunity. Circa 1940s. *Courtesy of Mike F. Miron.*

The biggest surge in sailing followed World War II with a number of original designs featured from Annapolis, including the *Blue Moon* from Thomas Gillmer and three boats from John Trumpy at Trumpy Yachts—a waterline sloop, a centerboard ketch and a motorsailer.[147] Twenty-five years later, boat designer Bruce Farr arrived in Annapolis from Australia and went on to design state-of-the-art high-performance ocean racers.[148]

Also during the interwar period, enthusiasm for powerboating picked up in Annapolis, a trend that was paralleled up and down the East Coast. The Annapolis Power Squadron organized at the AYC in 1941 with 36 members, a number that grew to 150 in just eight years. Just as with the club at the time, women were not eligible for membership, but any woman who passed the exam did receive a certificate.[149] There is no definitive research on the number of husbands who allowed their certified wives to drive or (gasp) women who owned their own powerboats in 1941.

While boating was quickly becoming an American pastime, African American enthusiasts faced exclusion from boat clubs and were often turned away from public fuel docks and marine stores. Originally founded in Washington, D.C., in 1946, the Seafarers Yacht Club came to Eastport in 1949, when a group of African American boaters formed a local chapter.[150] The men held meetings at one another's homes until they purchased and renovated an old Eastport schoolhouse, turning it into a yacht club near Back Creek that remains popular today.

By the mid-1950s, powerboating and sailboat racing were well on the way to becoming Annapolis's top pastimes and significant sources of the city's revenue. The sailboat races still favored long distances, with short 'round-the-buoy courses popular today still twenty years away. The one local annual regatta at the time featured six one-design fleets, or groups of sailboats all of the same

class, with only a few that remain today, including the classic sailing dinghies, Comet and Hampton.[151] The annual regatta in the 1950s was a rather formal occasion. Annapolis race judges, like their counterparts in New England and New York, were dapper gentlemen dressed for the high event in white shirts, ties, jackets and appropriate commodore hats, no matter the weather.

The formality of the coats and ties from the early days of racing was replaced with polo shirts emblazoned with yacht club emblems and the more practical, albeit expensive, synthetic waterproof foul weather gear of the past several years. The modern-day racing scene is one distinctive feature that separates Annapolis from other sailing towns—every night of the week, except Monday, there is a race in Annapolis.[152] The most popular is the Wednesday Night Race, first sponsored by the Annapolis Yacht Club in 1959 and inspired by a similar midweek race in Rhode Island. The next so-called "beer can" race, nicknamed for the party afterward, is the AYC's Frostbite Series, which began in 1962. Only for the hardiest of sailors, these Sunday afternoon races are held during the frigid winter months, when captains and crew hope for a vigorous race to help keep them warm. As much for safety as for comfort, the rules of the Frostbite Regatta restrict any crew member from leaving the safety of the cockpit during the race. While racers love to joke about falling overboard during the confusion and mayhem of a Frostbite race, that could potentially prove fatal, and despite the name, nobody really wants to be frostbitten.

In the late 1970s, in the days of John Lennon and the Beach Boys, a small group of local sailors was looking to start a yacht club with unrestricted membership in a more relaxed environment. One of the founding members of the Eastport Yacht Club, Fred Hecklinger recalls the motivation behind the new club:

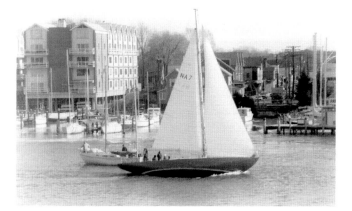

Naval Academy participants in the weekly winter Frostbite Races race for the finish line on Spa Creek. Notice the ice forming across the creek closer to Eastport. December 1977. *Courtesy of the Annapolis Yacht Club.*

The Annual Sock Burning at the Eastport Yacht Club, 2008. This tradition marks the end of winter and the beginning of the busy season for boat workers. *Courtesy of Al Schreitmueller, SpinSheet.*

If an AYC member wanted to go to their own bar on Tuesday or Wednesday afternoon they had to have a tie and jacket on. If you work in the marine industry you don't wear a coat and tie so if you wanted to have a drink at the club at 5pm, you had to go find a coat and tie.

This was not your jacket and tie kind of crowd. In fact, the first meeting of potential members in October 1980 was held at an Eastport pub called Marmaduke's, a hangout for the hardcore sailing crowd whose memory causes people to either smile or wince. The number of potential charter members was chosen by how many people could fit in the upstairs, above the bar. Capacity was two hundred people, and thus the Eastport Yacht Club was founded.[153] The club opened its new clubhouse thirteen years later on Spa Creek, across from the Naval Academy. Still a fun-loving group, the EYC hosts a number of significant races and other sailing events throughout the year, including its popular "Box of Rain" fundraiser. The Boatyard Bar and Grille replaced Marmaduke's as the local sailors' hangout and hosts an annual regatta, weekly video screenings of the Wednesday Night Races and fishing tournaments.

There are many other yacht and sailing clubs in Annapolis today. The fifty-year-old Severn Sailing Association (SSA) on Spa Creek is dedicated to one-design racing and other sailing events, but the crown jewel of the SSA is its children's sailing program. There are a number of clubs in Annapolis that exist on paper, such as the local chapter of the Corinthian Yacht Club, amateur sailors dedicated to fellowship, and the Sailing Club of the Chesapeake. The members participate in races and regattas but do not have a clubhouse, a dock or, heaven forbid, a bar. Annapolis hosts a large number of "live aboards," people whose home-sweet-homes lie tied up in a slip at

Sailors from all over the bay prepare for a long night at the start of the annual EYC-sponsored Annapolis–Solomons Island race held every July. *Courtesy of Dan Phelps, SpinSheet.*

a marina. Many are cruisers, boating enthusiasts who sail or powerboat to wherever they like for as long as they like.

Unknown to even longtime Annapolis skippers is a group that began in 1955 called the Slocum Society. Named after Joshua Slocum, the famous professional seaman to first sail around the world single-handed, the Eastport-based club published a newsletter, called *Spray* after Slocum's famous boat, and was considered the best source on single- and double-handed voyaging. Special guest Dr. David Lewis, the only person at the time to circumnavigate Antarctica single-handedly, attended the club's anniversary celebration in the 1970s.[154] The club met until 1990.

There are two popular overnight races that have become annual rites of summer—the four-day Annapolis–Solomons Island (Maryland) race, sponsored by the Eastport Yacht Club, and a race from Annapolis to St. Mary's City in southern Maryland, called the Governor's Cup, sponsored by St. Mary's College. Annapolis has also been designated as a stopover for the highly visible international Volvo Ocean Race and its predecessor, the Whitbread Ocean Race. Possibly the longest-running overnight race, from Annapolis to Hampton, Virginia, now called Race the Bay, returns in 2009 after a ten-year hiatus.[155]

The booming popularity of boating was the genesis for the annual U.S. Sailboat and Powerboat Shows in Annapolis at City Dock. The idea originated with Gerry Woods, the owner of the Annapolis Sailing School, one of the oldest sailing schools in the country. Since 1970, thousands of boat enthusiasts have flooded downtown Annapolis annually to see the latest yacht designs. But many locals say that the best boat show ticket in town is for the Sunday evening between the Sailboat Show and the Powerboat Show.

The 1976 Annapolis Boat Show, long before everyone had to take off their shoes—even boat shoes—to go on the new boats. *Courtesy of Robert DeGast, Chesapeake Bay Maritime Museum.*

Crowds line City Dock and Spa Creek Bridge to watch the exceptionally well-orchestrated, but also extremely close, dance of the huge sailboats leaving the narrow City Dock to make room for the massive powerboats, the next show's main attraction.

The granddaddy of all yacht races is the America's Cup. This international regatta has been the penultimate challenge of yacht racing for over 150 years and has its origins with the iconic racing schooner *America*, which spent her last 27 years in Annapolis. The *America's* spectacular design by naval architect George Steers makes her, and the other Steers ships that followed, among the fastest and most seaworthy ships of their day.

THE FATE OF THE *AMERICA*

Dear to the hearts of yachtsmen everywhere is the racing yacht *America*, the namesake of the famous international race America's Cup, following her 1851 victory over fourteen British yachts. A sleek, elegant, two-masted schooner, the

101-foot *America* had a stellar, albeit widely varied career. Other than racing, it included such assignments as Confederate blockade runner and practice ship for Naval Academy midshipmen. At sixty years old, she was sold to the U.S. Navy for one dollar and was unceremoniously towed the eight-hundred-plus nautical miles from Boston to the Naval Academy in Annapolis.

For almost twenty years, the *America* was on display at the academy as a marine relic or, depending on who is asked, was left to die from neglect. President Franklin Roosevelt, who was a huge fan of sailing, thought that she would make a fine addition to his proposed National Naval Museum. At his request, Congress appropriated $100,000 in 1940 to restore the *America*. She was hauled out and put up on blocks at the Annapolis Yacht Yard on Spa Creek for repairs.

Annapolis Yacht Yard (AYY), like many other large boatyards at the time, was revving up to build warships for U.S. allies. Nonetheless, boat workers at the AYY systematically worked their way through the *America*, removing rotted wood and slowly making their way to firm timber. Over the course of her more than one-hundred-year career, the *America* had been sailed, sunk, recovered, shot at, raced again and left to sit idle in salt water—that there was anything left to her at all is testimony to her superior construction and design by George Steers of William Brown boatyard in New York.

Pearl Harbor quickly put an end to any work being done on the *America*, and a temporary roof was built over her skeletal frame. An unseasonable snowstorm on Palm Sunday in 1942 covered Annapolis with a whopping sixteen inches of wet and heavy snow. The weight of the snow collapsed the shed covering the *America* and crushed the historic yacht underneath it. Longtime AYY worker Charles Dawson was standing in the doorway of the shed closest to the *America* and was blown back several feet. Fortunately, no one was hurt under the collapsed shed, but the same could not be said for the *America*. Split down the middle from stem to stern and covered with snow and debris, the *America* was destroyed.

Captain Richards "Dick" Miller was a twenty-three-year-old navy lieutenant at the time and was based at the yacht yard. With the *America* beyond repair, he recommended that she be disassembled and stored in pieces until after the war. "No!" was his commanding officer's immediate and resounding answer. In fact, he said, the yard was to put all available hands to work on rebuilding the *America* to have her sailing again by 1942. Lieutenant Miller was stunned. A nearly impossible task, even during peacetime, he protested that any work on the *America* would jeopardize the more important mission at hand—building urgently needed warships. The senior officer looked at Lieutenant Miller with a leveled gaze and lowered the boom, "Franklin wishes it so."[156]

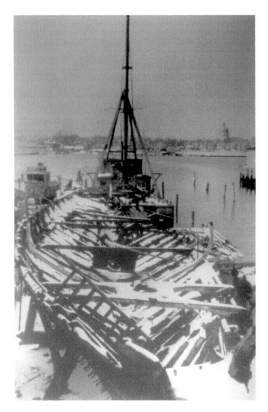

The *America* collapsed under a sudden Palm Sunday snowstorm in 1942. *Courtesy of Mike F. Miron.*

Luckily for Lieutenant Miller and the team at AYY, the navy had just issued a mandate that only building projects essential to the war effort could be undertaken. The *America*'s skeleton sat out in the elements, unattended, until the summer of 1942, when a new temporary shed was built over it. In September 1945, to honor the *America* and all of her past glory, the chief of naval operations ordered a model of the *America* built using what wood could be salvaged.[157] The model was completed in 1948, and its whereabouts today are unknown.[158]

Meanwhile, piece by piece, the *America* slipped away. Most of her materials were taken by resourceful people in Annapolis. Lamps and pieces of furniture made out of the *America*'s timbers are in some Annapolis homes, and a local marine surveyor even made several half models of the ship from the salvageable wood. A few of her sturdy oak planks were discovered under the dirty work boots of a local Eastport boatyard worker, used as scaffolding and covered with splattered paint. The mighty main mast of the *America* lay in the parking lot of Arnie Gay's boatyard at the foot of the Spa Creek Bridge in Eastport, decimated by termites, from the 1940s to the 1970s.[159]

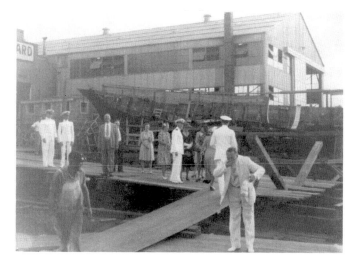

In a rare candid photo, one of the owners of the Annapolis Yacht Yard tries to recapture some of the remaining champagne from a boat christening. The *America* is in the background. Circa 1942. *Courtesy of Mike F. Miron.*

Captain Dick Miller, also an avid sailor, made his own half model of the *America* in 1943 or 1944. It is a half model that tells the entire story of the *America* and the busy Annapolis Yacht Yard during World War II. Included in the sculpture is wood from the *America* that is dark from nearly one hundred years of salt water saturation and a scrap of mahogany planking that was used to build the World War II patrol boats at AYY. Yellow pine from the subchasers also built at AYY was used to make the half model's sail, and the nameplate is made from one of the *America*'s bronze boat nails, polished on one side.[160]

TRUMPY'S LUXURY YACHTS

When one of the two owners of Annapolis Yacht Yard passed away in 1947, the five-acre property in Eastport was sold the next year to John Trumpy of New Jersey, owner of the renowned luxury wooden motor yacht company of the same name. After thirty-five years in New Jersey, Trumpy was tired of the increasingly polluted Delaware River and began looking for a new location. Because of its proximity to the inland waterway and its position on the Chesapeake, Annapolis was perfect. The Trumpy operation rolled into town with eighty truckloads of tools and equipment. Retaining most of the key employees of AYY, Trumpy instantly became Annapolis's biggest employer in 1948, with 130 workers.

A Trumpy motor yacht was the height of luxury, and the *New York Times* called the boats the "Rolls Royce of American motor yachts." Trumpy built about six yachts per year and sold them at the then astronomical price

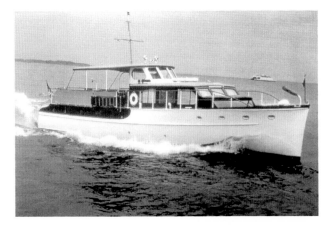

A Trumpy luxury yacht on Spa Creek, with the Mattateke Ferry in the distance. The ferry made regular runs between Annapolis and Eastern Shore before the Bay Bridge put it out of business. Circa 1950. *Courtesy of Sigrid Trumpy and Donald Trumpy.*

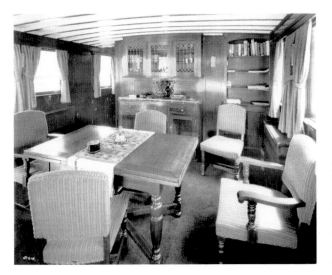

Everything in a Trumpy yacht was handcrafted at the Eastport yard, including the interior furnishings. Circa 1947. *Courtesy of Sigrid Trumpy and Donald Trumpy.*

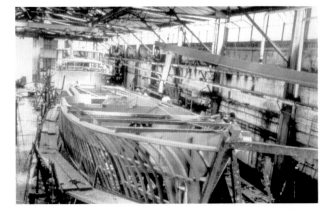

One Trumpy yacht is planked, while the one behind it is nearly done in the yard's Big Shed. Renovated in 2008, the Big Shed is now Class-A office space. *Courtesy of Sigrid Trumpy and Donald Trumpy.*

of $200,000 to $400,000, with every boat detail handcrafted at the yard, including bronze hardware and interior furnishings.

By the 1950s, John Trumpy & Sons, Inc. had become a national phenomenon with the development of the elegant shoal-draft power houseboat. The yard and its fourteen different departments buzzed constantly with activity. The yard employed twenty-eight master ship carpenters, some second- and third-generation carpenters and some who learned the craft at AYY or Chance Boat Construction, which preceded AYY. Trumpy was the only elite specialty marine yard between New York and Florida at the time.[161]

Eight years later, the Trumpy operation began a downturn, from which it would not fully recover. A massive fire, assumed to have originated in the lumber shed, consumed nearly the entire yard one cold night in 1962. One year after the fire, almost to the day, John Trumpy Sr. died, leaving the boatyard operation to his sons Donald and John Jr.

Eastport was growing and Trumpy's carpenters began to leave the boatyard to work in the construction business at almost twice the hourly wage. The remaining boatyard workers asked for a raise and benefits but were turned down by management, ultimately resulting in a strike. The devastating fire and bitter strike took their tolls, but a technological development in the construction of boats would be the third element in a perfect storm that would end the glamorous era of Trumpy Yachts.

Fiberglass was making boating more affordable for Americans, but John Trumpy Jr. ignored the growing market and remained steadfast in his dedication to the traditional, painstaking craftsmanship of wooden yachts. With the low cost and easy maintenance of fiberglass boats, interest in new custom wooden luxury yachts waivered, and the final Trumpy classic luxury wooden yacht was launched in 1973.

Boatbuilding for Trumpy was over, but the waterfront property still had promise. In 1974, the concept of condominiums was new but spreading quickly, just like the multiunit buildings themselves. John Trumpy Jr. pursued plans for a 156-unit condominium complex on the boatyard property, but the city turned down his request, citing the need to preserve the maritime character of Annapolis. Following the defeat, and disheartened by the changes in building yachts, John Trumpy Jr. reluctantly put the property up for sale and retired to Florida.

Annapolis City Dock, its harbor and the Chesapeake Bay began as waterways that brought successful trade to Annapolis, allowing it to prosper and grow. In a natural evolution, the same waters became the center for today's pleasure boaters and recreational sailors. These useful and peaceful waterways have also been the sites of conflicts and battles that helped determine the fate of America—yet another chapter in Annapolis's maritime history.

CHAPTER FOUR

ANNAPOLIS IN WARTIME AND THE UNITED STATES NAVAL ACADEMY

The few hundred colonists who first settled along the Severn River in 1649 were mostly Puritans, or Protestants, and some Catholics, seeking religious tolerance in Maryland's wilderness.[162] The new settlers faced harsh winters and mosquito-plagued, humid summers while they set about farming and harvesting food from the bay. After six short years, in 1655, armed conflict would disturb the settlers' quiet lives. Over one hundred years before the Revolutionary War, a peninsula at the mouth of the Severn was the site of the first civil war fought on the North American continent.[163]

The conflict stemmed from the civil war in England, which pitted Roman Catholics against the Protestants. Maryland's governor, William Stone, insisted that all settlers take an oath of fidelity to Lord Baltimore, a Catholic. Anyone who did not would have his land confiscated. The Puritans of Providence refused to take the oath of allegiance to Lord Baltimore—religious freedom was the very reason they had settled in the remote region of the Chesapeake. The settlers had come too far for religious freedom to give it up without a fight. Governor Stone ordered his Cavaliers to sail up the Chesapeake Bay to enforce his will.

Although severely outnumbered and underequipped, the settlers handled themselves well. The skirmish began with a drum roll and a challenge from the Cavaliers, "Come, ye rogues; round-headed dogs!"[164] The fight took place on the tip of the Eastport peninsula, called Horn Point, and it was brief. In just thirty minutes, the settlers managed to drive the governor's force of 150 men to the end of the point, where the Cavaliers were defeated by the settlers.[165] For three years, the Puritans maintained control of their settlement before an uneasy but workable truce was struck—religious tolerance for the colony in exchange for its recognition of Lord Baltimore's rule. Local historian J. Wirt Randall called the battle "the occasion on which Americans first baptized with their blood the soil of this continent and dedicated it to Freedom."[166]

COLONIAL ANNAPOLIS GOES TO WAR

Eighteenth-century Annapolis grew in population and prosperity and gained the confidence that comes with being self-sufficient. Like the other colonies, Annapolis paid a tax on every shipment that came into port, including deliveries from other colonies. As success steadily increased, so did taxes, until the colonists' modest independent trade was slowly and maddeningly eliminated.

The colonies' Non-Importation Agreement was circulated in Annapolis in 1774, but not everyone signed the document that protested the various tax burdens such as the Stamp Act. Operating quietly on the sidelines to subdue the protest were British sympathizers who remained in Annapolis instead of returning to England. Anthony Stewart was likely one of those men and the source of the so-called Annapolis Tea Party, a good example of the split loyalties and level of violence in Annapolis leading up to the Revolutionary War.[167]

In 1774, Stewart waited patiently for his ship, the *Peggy Stewart*, to sail into Annapolis Harbor. Named for Stewart's daughter, the old, leaky brig was loaded with indentured servants bound for auction and over two thousand pounds of tea, a hot commodity in colonial Annapolis. The ship arrived, and Stewart quietly paid the required tax on the tea. When word of this got out, an angry mob charged up to Stewart's house, confronted him and demanded that he join the fight against taxation. Dissatisfied with Stewart's explanations, the crowd gave him a grim choice—burn the ship "or be hanged right here at your front door." Reason was not on Stewart's side. He feared for his safety, and that of his wife, who was nine months pregnant and due to give birth at any time. At a public hearing, Stewart presented his best case. The brig was leaky, he said. He was concerned about the safety of the passengers and was forced to unload the ship. After a series of escalating offers to appease the court and the angry crowd that had assembled, Stewart reluctantly agreed to burn the tea and the ship and publish a letter of apology in the local paper.

With a large crowd on the banks of the Severn River, Stewart and two local merchants, the intended recipients of the tea, ran the *Peggy Stewart* aground in the Severn River and set her on fire. Financially ruined, and his life still threatened, Stewart and his family fled for London, where he was given an annual pension for the loss of the *Peggy Stewart*. The remains of the *Peggy Stewart* are now covered by Luce Hall at the United States Naval Academy, built on land created from dredging in the 1800s.[168]

With neither Britain nor the colonies willing to concede, Annapolis had good reasons to fear becoming a primary target for the British. The city was superbly

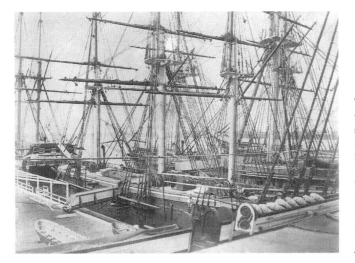

These schooners were the station ships for the Naval Academy midshipmen in 1873. The photo was taken from the deck of the USS *Constitution*. *Photo courtesy of the United States Naval Academy Archives.*

located for storing and distributing supplies to Continental forces, and it already had several well-outfitted shipyards for building and repairing warships. As the drumbeat of war began, lookouts were stationed on the waterfronts.

The *Maryland Gazette* kept the city up to date with reports of British warships off Annapolis, much like the following item printed on November 21, 1776: "British fleet last seen off Sandy Hook, destination unknown, Council of Safety warned of possible invasion." To further protect its harbor, several modest forts were built on the Annapolis waterfront, including one with fifteen cannons at the end of Horn Point. If Annapolis colonists wanted to help win the war, they had to protect and use their rivers, their harbor and the Chesapeake Bay.

Annapolis struggled to keep up with the business of war with storing food, guns and ammunition in warehouses on the City Dock and outfitting and training Continental army troops from around Maryland before they were shipped to battle. In August 1777, the *Maryland Gazette* reported that an astounding two hundred British warships had passed Annapolis Harbor one evening, with many remaining nearby in the bay.

Getting supplies to the Continental ships waiting outside the blockade was dangerous business for Annapolis privateers, now organized into the new Maryland navy. The colonists learned to rely on their smaller, shallow-draft boats, which could outmaneuver the slower, larger and deeper-draft British warships around the shallows of the harbor and bay. Constant attempts at dodging and outrunning the enemy gave Annapolis a chance to continue to successfully supply the war effort.

Maryland privateers also captured British ships loaded with supplies such as muskets, uniforms and food, but Britain was doing its own damage to

the colony. In 1780, Maryland governor Thomas Sim Lee wrote his second letter to the Continental Congress, pleading for relief from the attacks on merchants traveling in and out of Annapolis and Baltimore. The heavily armed British warships were wreaking havoc on the bay. The dire situation was compounded by small gangs of Loyalists and privateers ambushing and raiding Continental ships from the safety of the hundreds of small coves and inlets on the Chesapeake Bay. Governor Lee's letter, like the first, would go unanswered, and Annapolis, like other Maryland cities, was left to defend itself.[169]

That same year, the Marquis de Lafayette and twelve hundred of his Light Infantry troops were preparing to join General Washington in Virginia. Most of the troops were on ninety Maryland vessels outside Annapolis Harbor, with Lafayette and the remainder at an encampment at the foot of today's Spa Creek Bridge in Eastport.

Before the two units could unite, two British warships, the *Hope* and the *Monk*, each with eighteen guns, blocked Annapolis Harbor, effectively trapping Lafayette on shore. Lafayette sent some of his troops overland to Virginia while he devised a way to slip past the large and heavily armed ships. Meanwhile, the two British ships attacked every merchant who tried to approach Annapolis and attacked and set fire to an important shipyard on the West River, just a few miles from Annapolis. Lafayette and all of Annapolis could see the fire rage long into the night.

Six days later, Lafayette had field weapons mounted on the bow of a small sailing sloop, with his remaining troops stationed on a few other boats. Lafayette launched a surprise attack on the mighty warships, chasing them down the bay.[170] Lafayette referred to his success, or "experiment," in a letter to Thomas Jefferson:

> *I wish it was possible to fix some heavy cannon upon small vessels so as to make floating batteries. I have lately tried the experiment at Annapolis and could derive great benefit from it.*[171]

Armed British warships remained a constant sight from Annapolis Harbor and on the Chesapeake Bay. The warships harassed the Continental army's supply and troop movements and plundered the villages and farms along the Eastern Shore. Despite a number of close calls, Annapolis remained relatively unscathed throughout the war and went on to host the signing of the Treaty of Paris in 1784, which, for the time being, officially ended hostilities with Britain.

A TEMPORARY PEACE

Following the Revolutionary War, Annapolis experienced a quick postwar boom in trade and, like cities in the other former colonies, let down its guard. Forts and fortifications fell into disrepair and the city was lulled into a peacetime routine.

In 1794, following reports of dueling blockades between France and England, President Washington called for fortifications at twenty American seaports, including Annapolis. The war between England and France began to escalate, and just as the new president had feared, America and its crucial maritime trade were caught dangerously in the middle.

By 1812, Annapolis had two new forts—Fort Severn on a point of land that is now the U.S. Naval Academy and Fort Madison on the north side of the Severn River on Greenbury Point. Fort Severn was a massive circular rampart, one hundred feet in diameter, with ten heavy, mounted guns and a furnace for heating shot at the fort's core. A wooden fence surrounded Fort Severn, which the new commanding officer, Captain Norris, U.S. Army, immediately ordered removed, stating, "It is bad enough to be killed by the balls of the enemy and not by our own splinters."[172] Fort Madison was similar but larger, with thirteen guns. The battery on Horn Point in Eastport was reestablished, and low wall fortifications lined the town's waterfront. The city and its three thousand residents were ready to defend themselves.

A year later, in 1813, twenty British Royal Naval ships anchored off the Annapolis Roads peninsula, well within sight of downtown. Annapolis captains who attempted to run through the blockade risked being captured and having their goods confiscated. War raged up and down the Chesapeake Bay, and each time the English warships moved, there was a call to arms. One night, a guard at the Horn Point fort startled the city by firing the alarm guns, which meant that the British were about to land at Annapolis. Fortunately, it was two Annapolis ships that had forgotten to give the proper signal on approach.[173]

After the war, Annapolis and the rest of America quickly returned to the everyday rhythm of peacetime. Of the lessons learned from two wars in twenty-five years, chief among them was the recognition that if America wanted to protect its shores, it needed to heed the call for a trained navy.

THE U.S. NAVAL ACADEMY RESCUES ANNAPOLIS

John Paul Jones, the famous colonial naval war hero and the father of the United States Navy, was the first to promote the idea of a naval academy.

Jones was inspired in 1783, when he saw the well-trained and educated French navy's student officers. But the success of the French was of no consequence to the decision-makers in Washington, D.C., who preferred the British method of teaching young naval officers out in the fleet. Besides, lawmakers argued, the British won their naval battles; the French did not.[174]

For the next sixty years, official recommendations for a formal academy were made by one inspector general of the army, seven different secretaries of the navy and one president, each without success.[175] Even with the advent of the steamship, when a ship's captain needed sophisticated, technical knowledge to navigate and operate steamships, Congress showed no interest in a naval academy. Midshipmen were schooled, trained and quartered on ships operating in the fleet.

For the nation's lawmakers and many senior naval officers who learned their trade at sea, the idea that midshipmen should be taught in a classroom on land was laughable. How could anyone learn to sail the mighty fleet of the United States Navy by sitting at a desk on land? As one senior officer at the time put it, "You could no more educate sailors in a shore college than you could teach ducks to swim in a garret."[176]

In 1842, the U.S. government implemented its own plan to educate midshipmen. Following Britain's method, navy ship's chaplains were assigned the task of teaching young midshipmen on ships, despite the chaplain's own limited knowledge of important subjects like coastal navigation.[177]

The 103-foot American brig *Somers* left Brooklyn, New York, on September 13, 1842, for training midshipmen on the high seas. There were 121 men onboard, five of whom were over thirty years old, including the gentle and intellectual captain, Commodore Alexander Slidell MacKenzie.[178]

Also onboard was midshipman Philip Spencer. The fact that Spencer was the nineteen-year-old son of then Secretary of the Navy John Canfield Spencer should have given him a head start. Instead, young Spencer's version of "leadership" would end in tragedy on one of the most fateful cruises in American naval history.[179]

The *Somers* had a successful sail out across the North Atlantic to Madeira, Tenerife and the west coast of Africa. After two months at sea, the *Somers* started the trip home, with a stop at St. Thomas in the West Indies for provisions. Two weeks into the return trip, the ship's steward reported that he had been invited to join a mutiny organized by Midshipman Spencer. Spencer's plan, with two enlisted navy men in cahoots, was to take control of the *Somers*, murder her officers and anyone on the crew who did not join their mutiny and go on to the West Indies to live exciting and prosperous lives as pirates.

Written notes found on Spencer confirmed the plan for mutiny, and since there wasn't a brig, Spencer was chained to the quarterdeck. However, the conspiracy was more widespread than was originally thought, and six seamen who also supported the plan for mutiny were arrested and chained to the quarterdeck.

When discipline continued to deteriorate, Captain MacKenzie ordered a court of inquiry of the *Somers*. The news was grim. Swift and severe punishment was recommended for the mutineers—"the safety of [this vessel], the lives of ourselves, and those committed to our charge require that they should be put to death."[180] Captain MacKenzie wasted no time; he had the original three mutineers hanged from the yardarm of the *Somers*, high above the *Somers*'s officers and crew.

Two weeks later, when the *Somers* arrived back in New York, the secretary of the navy, young Spencer's father, had MacKenzie brought up on charges ranging from murder to conduct unbecoming of an officer. Luckily, Spencer had confessed before he was hanged—he had even bragged that he had tried it two other times before his cruise on the *Somers*. "It seemed to be a mania with me," he said.[181] Captain MacKenzie was exonerated and acquitted on all counts.

Aside from the *Somers* incident, teaching the midshipmen onboard ships was just not working. The captains did not support the plan, and the chaplains, who weren't trained for the task in the first place, were grossly underpaid and often quartered with their reluctant students. Three years after the *Somers* incident, through some clever manipulation by the new secretary of the navy, America finally got its Naval Academy.

President John Polk appointed scholar and politician George Bancroft secretary of the navy in early 1845. At the remarkably young age of twenty, barely older than the midshipmen themselves, Bancroft took office. He had no naval experience but liked the idea of a naval academy, and he wasted no time getting it started.

Too clever to try the same route as the secretaries before him, Bancroft shifted around existing funds to hire naval instructors and secured the obsolete army post in Annapolis, formerly Fort Severn, for the new academy, all within three months of his appointment as secretary. Bancroft then hired his friend and Maryland native Commander Franklin Buchanan as the first superintendent. With that, the deed was done, and without any assistance from Congress, the United States Naval Academy was founded.

The Naval School, as it was called, would emphasize academics, practical experience and, of course, training on the water. It opened on October 10, 1845, with two officers, seven professors and forty midshipmen.

A History of Watermen, Sails & Midshipmen

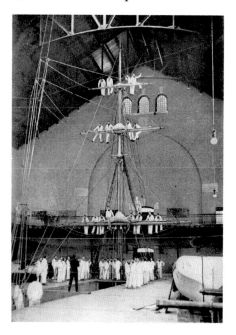

Apparatus for indoor training in ship handling, circa early 1900s.

Annapolis was thrilled with the new Naval School. As a happy coincidence, Annapolis had lobbied for twenty years to be the best location for a naval school. In addition to its proximity to Washington, D.C., and its superior water access, there was also a desperate need behind the city's request. Annapolis had fallen into a steady decline, with much of its critical maritime trade gone to nearby Baltimore.

By the time the academy opened, Annapolis had become a sleepy little market town of about three thousand residents, stately Georgian mansions, elegant St. John's College and not much else. There was, however, a lot of activity taking place at the dirty, odorous and crumbling downtown City Dock, where watermen and seafood merchants were laboring to keep up with a burgeoning oyster trade. Nonetheless, the relatively quiet seclusion of Annapolis appealed to Bancroft; he preferred to keep the young men away from "the temptations and distractions that necessarily connect with a large and populace city."[182]

CIVIL WAR AND THE NAVAL ACADEMY

Annapolis, like the rest of Maryland, was at odds with itself in 1860. Civil war was on the horizon, and loyalties were divided. Maryland, a Southern border state, still allowed slavery but had declared its loyalty to the Union,

against the wishes of much of Annapolis society, who would have preferred that Maryland join the Confederacy. A year later, the Naval Academy began to react to the news of civil war—extra men were ordered on watch and howitzers were placed at the entrance gates. The new superintendent, Captain George Blake, was particularly concerned about a possible raid on the longtime training ship and hero of two wars, the *Constitution*, "Old Ironsides." Under orders, cannons from the battery were placed on the ship, and the guards onboard were armed with pistols. Armed midshipmen provided backup in case of attack. Blake devised an evacuation plan in the event of an attack on the academy: First, destroy the munitions supply, then load all 250 midshipmen on the *Constitution* and sail north.[183] When war appeared inevitable, many Southern-born midshipmen submitted their resignations to join forces in the South. Ironically, the would-be Rebs had to wait for their resignations to be approved before they could mobilize south.

Not every Southern midshipman joined the Confederacy, however. Virginia-born Robley D. Evans, class of 1864, decided against following his fellow Southerners and instead joined the Union forces. His mother intervened and took the liberty of resigning for him. In what must have been an awkward moment, Evans was able to convince the Navy Department that, regardless of how his mother felt, he knew what he was doing.[184]

Following heavy rioting in Baltimore in 1861, rumor spread that Annapolis was next, and the beloved *Constitution* was the primary target.

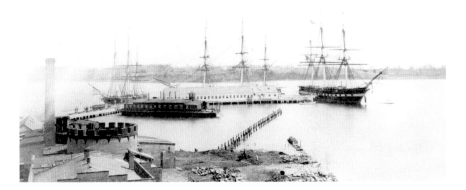

Gunnery and practice ships at the academy's Santee Wharf, including the USS *Dale*, a sloop of war dating back to 1839, and the USS *Wyandank*, a New York ferry used as barracks for U.S. Marines from 1865 to 1879. The building in the foreground is the academy's new power station. The academy was the first public institution in the New World with central heat and light. Circa 1870. *Photo courtesy of the United States Naval Academy Archives.*

She had to be moved away from the academy wharf but kept close enough for the midshipmen to board in the morning. To sail her into deeper water on such short notice, Blake borrowed volunteer militia—really fishermen from Massachusetts—from the nearby Union ship *Maryland*, which had just arrived in Annapolis Harbor with General Benjamin Butler and his Union troops. It was not a smooth operation. The *Constitution* ran aground three times before a passing steamer pulled her into deeper water, where she waited for the midshipmen to board by steamer and sail for Newport, Rhode Island, the temporary base for the academy.[185]

Simultaneously, General Butler and his troops began to set up a massive army encampment on the academy grounds, with another across the river at the fort on Horn Point. The academy yard was quickly transformed into an army camp, with a flood of troops, tents, supplies, artillery and ammunition. The first-class midshipmen gave up their rooms for the army's senior officers.[186]

The next morning at roll call the midshipmen assembled on the wharf to be ferried to the *Constitution*. The twenty Southern midshipmen who were still waiting for their resignations to come through fell into formation as well, even though they would stay behind.

As Admiral Charles Clark, one of the midshipmen present, recalled, it was an emotional morning for everyone as the battalion mustered. Commandant of midshipmen Lieutenant Christopher Rodgers walked down the line of the young men as the academy band played "The Star Spangled Banner." According to Admiral Clark's account, the young faces looked at Rodgers expectantly as he searched for the right words. He raised his hand, pointed to the flag waving over their heads and said, "Be true to the flag!" Then, he broke down. Many followed suit. Some of the Union soldiers from Butler's army jumped in and reassured the midshipmen with bear hugs and assurances that they would return to the academy. "You'll get your school again!" they promised.[187]

With the midshipmen on their way to Newport, the academy effectively closed, and downtown Annapolis began to fill a familiar role as an important military port during war. Troops, weapons and provisions arrived and departed daily from the main depot on the Naval Academy wharf. The army post and hospital made the academy yard unrecognizable as thousands of Union troops and supplies poured in from the North. General Butler was the commanding officer of the new Department of Annapolis, as it was called, and had the railroad extended into the academy and a row of massive storehouses built along the shore of the Severn River to accommodate the wartime supplies. The hectic pace only increased. A year later, over thirty thousand Union soldiers assembled for a joint army-navy operation to take

place in the Carolinas, occupying the combined areas of the academy yard, the adjacent St. John's College campus and Camp Parole, north of downtown.

During the conflict, hundreds of Confederate soldiers were brought to Annapolis as prisoners of war, but not everyone was unhappy about that, as was reported by the *Evening Gazette* on September 1, 1861: "Ladies of southern proclivities paid them [Confederate prisoners] marked attention."

It proved to be difficult to keep the academy together during the next four years. The temporary academy was based at Fort Adams in Newport, and life for the midshipmen was miserable. Quarters were in the crumbling old stone Fort Adams, food was barely tolerable and showers were allowed just one day a week. Classes of midshipmen were graduated early to join the fight, and the academy's leadership ranks thinned out as officers were ordered to sea and new officers wanted to fight in the war instead of teach. On the positive side, the academy's annual summer training cruises were far more exciting with the Civil War raging around them.[188]

Following the Confederate collapse in 1864, the academy returned to its initial mandate, Annapolis, but it was not an entirely happy homecoming. The grounds were decimated after years of use as an army post, as described in a letter signed only as "Graduate," printed in the *Army and Navy Journal* on October 22, 1864:

> *My eyes were struck by the view of a number of hospital tents occupying the grounds…the roads and pathways across grounds, a crossing of which once subjected a student to demerits. The fine old quarters of the Superintendent are used as a billiard saloon. Thousands of dollars will be required to restore this valuable institution to its original condition.*[189]

Worse than the physical damage to the yard were the sad condition of the academy's academics, military standards and the morale of its midshipmen. When the academy reopened in the fall of 1865, the grounds were restored, and academics and morale were on the mend, with Rear Admiral David Dixon Porter as the new superintendent. Porter was a decorated veteran and second-generation military man. It was during Porter's tenure that the academy experienced the greatest land expansion and construction of new buildings. It was also during this time when America's first naval hero, John Paul Jones, was brought to the academy and interred in the new Chapel's crypt.[190]

Peace again reduced the country's focus on the military, and Congress cut the number of men allowed into service but created a new opportunity for the graduates in 1881 with an option to join the Marine Corps.

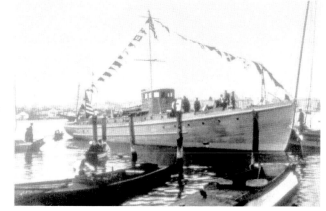

A 110-foot submarine chaser ready for launch at Chance Marine in 1918. The sequence of signal flags was inspected before flying to avoid foul language. *Courtesy of the John Kelbaugh Collection.*

This reduction was ill-timed, however, and the outbreak of the Spanish-American War in 1898 caused a surge in academy attendance. The academy filled military ranks, as it had during the Civil War and every major war that followed, by accelerating graduating classes of midshipmen.

Fifteen years later, the country and its military prepared to enter the First World War. The academy's accelerated classes turned out enough ensigns for the navy's impressive fleet of more than eighty new warships, all built in just three years, some of them in Annapolis.

Years later, the approach of World War II brought an even more radically compressed graduation schedule—the classes of 1941 and 1942 graduated early and a three-year curriculum was instituted beginning with the class of 1943. The number of Naval Academy graduates from 1941 to 1945 holds the record today, at seventy-five hundred.[191] The sea wars in which the midshipmen fought, particularly during World War II, were the greatest ever. Before the end of 1945, the United States Navy became the most powerful naval force in history, thanks to ships built in American cities and towns like Annapolis.[192]

ANNAPOLIS AND THE WORLD WARS

On April 1, 1918, the *Annapolis Advertiser* newspaper had the following World War I update on the homefront:

A fleet of 15 Swift Submarine Chasers, recently constructed at various shipbuilding yards throughout the country, arrived here late yesterday afternoon from an Atlantic port, and remained over night. They cast their anchors in the

river off the Naval Academy...This type of war vessel, designed to wreak destruction to the sneaky submarine that has played so important a part in the great world war, is being built at a cost of over $100K each, complete. They are 110 feet in length, 15.5 feet beam, and are equipped with powerful gasoline engines capable of driving them at a speed of 25 miles per hour or more. Three of these craft were constructed by Chance Marine Construction Company, which has shipyards in Eastport. The last was completed a few weeks ago, and all are now said to be in active service of the government.

Situated within sight of the Naval Academy, Chance Marine Construction was one of many East Coast boatyards to receive government contracts to build warships. It was 1917, and America was entering the world war in Germany and France. New immigrants, older men and high school boys filled the boatyard ranks to complete the construction of four 110-foot wooden submarine chasers, heavily armed boats built to hunt down the German U-boats, or submarines, that dominated the seas.[193]

Just before the war, Chance was a busy boatyard hired primarily for building and repairing Chesapeake Bay work boats. After the war expansion, during the Roaring Twenties, business was good, and Chance was one of the most prominent names on the East Coast for yacht construction and repair. Ten years later, unable to pull out of the Depression, Chance Marine followed the path of many American companies and fell into bankruptcy. The boatyard was eventually sold to four men from New York who formed the new Annapolis Yacht Yard.

Annapolis Yacht Yard principals Chris Nelson, a naval architect, and Eric Almen, a yacht broker, opened their new yard with a focus on building custom yachts and providing high-quality repair. The AYY's first orders were for two twin–Diesel motor yachts and one fifty-four-foot ketch, and negotiations were underway for ten additional yachts.

When World War II began in 1937, the Annapolis Yacht Yard had just opened, and the already busy and somewhat elite Eastport boatyard shifted gears and began to prepare for the new business of building warships. Big government contracts were being awarded to American boatyards, but Annapolis Yacht Yard was shut out by companies with close relationships in Washington, D.C. Frustrated, Chris Nelson traveled to England to secure a contract for AYY and came back with plans to build Vosper patrol torpedo boats (PTs), but every measurement was in metric.[194] Luckily for AYY, Congress and President Roosevelt enacted Lend-Lease, a program that allowed the president to direct supplies to the war effort without sacrificing U.S. neutrality, and AYY was quickly contracted to build twenty-eight 70-

City Dock, circa 1940. The Anne Arundel deadrise was a popular, locally made work boat built for tonging and crabbing. Built on the West River, it featured an aft cabin affectionately called a "doghouse." *Courtesy of A. Aubrey Bodine, © Jennifer B. Bodine, www.aaubreybodine.com.*

foot Vosper PTs for the Royal Navy and one hundred PTs for the Russians. The U.S. Navy awarded AYY another contract to build two 110-foot wooden submarine chasers; AYY would go on to build ten more.

Like other boatyards building warships, AYY quickly hired any and all available men not going to war. Some young men, like Robbie Parkinson of Eastport, entered the fight early by joining Britain's Royal Air Force. Heeding the call to arms in 1937, Robbie Parkinson and his best friend, Joe Alton, had gone to the recruiter's office in Baltimore together. Joe was rejected because he was colorblind, and Robbie went on to fly fifty-five missions.[195]

Robbie Parkinson was trying not to panic. Though barely out of his teens, the young American was already an experienced World War II fighter pilot, with fifty-four missions under his belt. On a mission over the continent, Parkinson's plane was hit, and he was forced to ditch before he could return to England. After hitting the water, semiconscious and disoriented, Parkinson heard the engine of an approaching gunboat, but it wasn't British—it was German. Fortunately for him, the crew on a British Vosper plucked Parkinson out of the water and hustled him below for medical attention while the boat came under heavy fire. As Parkinson lay in the bunk under the

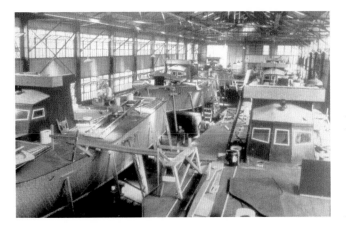

The Annapolis Yacht Yard built 128 PT boats by working around the clock, often building six at one time. Circa 1945. *Courtesy of Mike F. Miron.*

gunwale, wet, injured and exhausted, he opened his eyes, and the first thing he saw written on the underside of the gunwale was "Joe Alton," the name of his best buddy from his hometown of Eastport in Annapolis.

Many years later, Joe Alton told local historian Mike Miron, "I use to paint my name under the gunwale...I really thought they were my boats to tell you the truth, I was so proud of the work we did there [at Annapolis Yacht Yard]." Like the other men left in town during World War II, Joe Alton served his country with work at the Annapolis Yacht Yard, building Vosper PTs.

Joe Alton grew up with stories about the navy. His father, one of twelve children from a poor family, joined the navy and sailed with the Great White Fleet—President Theodore Roosevelt's ships that went around the world to show the American flag, displaying U.S. naval presence for the first time. It was Joe's father who helped Joe navigate through the difficulties of the cooling systems on the engines of the PTs. Despite his lack of education and relatively young age, Joe was invited to work at the drafting tables with the engineers in the boatyard loft, drawing complicated sketches of the piping system, much of it his own design. The work was superlative, and Joe knew it.

Young and brash, Joe didn't make many friends among the old-timers, men who showed no interest in the young upstart. Admittedly cocky, Joe borrowed his sister's camera one day and took pictures of all the intricate systems he had helped design and build, including the entire engine system. He proudly sent the pictures out to be developed, but they never came back. Instead, Joe received some important visitors a couple of weeks later—Naval Intelligence, who came to interrogate him about the pictures.

The navy brass accused Joe of being a spy, and he was suspended from work. Called to appear in front of Naval Intelligence at the Naval Academy,

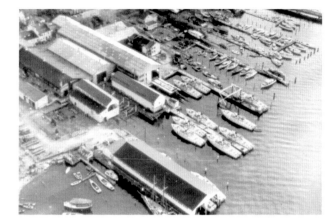

The Annapolis Yacht Yard, with nine Russian Vosper patrol boats (PTs) nearing completion. The *America* is under the shed in front of the PT boats. Circa 1945. *Courtesy of the John Kelbaugh Collection.*

Joe was a nervous wreck. A row of gold braid sat ready to question him, while a silver tray was wheeled in and coffee was served. Young Joe was convinced that he was being served his last meal. A commander on the board knew Joe and his family and spoke up, saying, "Look, I've known this boy and his family forever. This is all ridiculous." With that, Joe was let go. He went back to work but never did get the photographs.[196]

Other boatyards around town also worked for the war effort. They would have outfitted some of the large recreational yachts and fishing boats, like skipjacks and bugeyes, for service as antisubmarine patrols in the Coastal Picket Patrol or Corsair Fleet. In many ways, the old work boats and yachts were perfect for the war assignment. They could stay at sea for long periods of time and go undetected by enemy submarines.

This was not arduous duty—until winter. Gale-force winds and subfreezing temperatures made for incredibly rough conditions. Standard equipment for the fleet included baseball bats and wooden mallets to help break the ice off the decks and lines.[197] In Richard Henderson's popular book *Chesapeake Sails*, Henderson provides excerpts from a captain's log from a Chesapeake schooner of the Corsair fleet, the *Tradition*, which was caught in a gale while out on patrol in 1942:[198]

> *13:10—Seas breaking over us badly, unable to heave-to properly due to confused seas and heavy gusts of wind causing ship to swing sharply, seas swept away ventilator, forward hatch cover, galley smoke head life raft…water pouring in…rising faster than pumps can remove it… Engine trouble, radio fading, gas in bilge…unless weather changes will require assistance.*

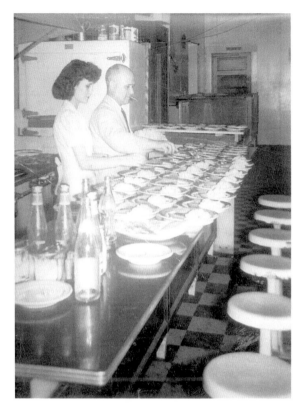

Sam Lewnes and niece Anna Lewnes (Hagner) prepare for the daily lunch rush of wartime boat workers at Sam's Corner in Eastport. The hot lunch was thirty-five cents, and Sam set the clock seven minutes fast so that the men wouldn't be late back to work. *Courtesy of the Lewnes family.*

A tow responded to a flare from the *Tradition*, and she took forty grueling hours to reach port, with more damage done from the strain of being under tow than during the storm.

Joe Alton and the other boatyard workers at Annapolis Yacht Yard, including some local women, got a new boss in 1947, when the AYY closed and John Trumpy bought the property. When the Trumpys moved in, they immediately assumed the AYY's navy contract for the all-welded aluminum PT-811, as well as seven unfinished AYY recreational boats. Even after the war, Trumpy Yacht Yard was Annapolis's biggest employer, with its fourteen different departments and extensive repair facility.

In 1950, President Truman committed the United States to the "police action" in Korea, and the custom luxury yacht yard switched gears again, becoming the nation's lead yard for the design and engineering of the MSB class minesweeper. It built eleven of the fifty-seven footers, and in 1953 a twelfth boat was built, the larger and more capable eighty-two footer known as the MSB 29 class minesweeper. Four years later, Trumpy & Sons, Inc. built six fifty-foot utility boats for the navy—nicknamed "liberty launches."

A History of Watermen, Sails & Midshipmen

In response to the perceived threat of communism, the U.S. government awarded Trumpy and Sons, Inc. a contract in 1956 to build ten forty-foot high-speed patrol boats, which were turned over to General Battista, president of Cuba, to fight against the rebel Fidel Castro. It was just seven years later when Congress gave President Johnson the go-ahead to defend U.S. military ships from attacks by North Vietnamese troops in the region. The boatyard stopped all other construction to build the six Nasty class PTFs (patrol torpedo boats—fast), eighty feet in length, with a twenty-five-foot beam that carried a crew of twenty-two and had a top speed of forty-five knots (fifty-five miles per hour).

These were important years for the boatyards in Annapolis. Government contracts kept the maritime trade alive and thriving, and the town contributed significantly to the efforts in numerous wars and conflicts.

THE NAVAL ACADEMY GROWS

The few run-down buildings that made up Fort Severn in 1845 were quickly insufficient for the growing Naval Academy. The USS *Santee*, a frigate that had survived quite a lot of action during the Civil War and was used to bring the midshipmen back from Newport, was renovated and used as quarters for the U.S. Marines and as classrooms for the midshipmen.[199] The need for expansion continued and the academy began to grow. Anyone who lived next to or relatively near the academy was likely to get elbowed out of the way. During its first fifty years, the Naval Academy acquired several adjoining private waterfront lots, including ten acres on Dorsey Creek, present-day College Creek, that belonged to St. John's College; land from downtown Annapolis that included the Maryland governor's mansion; and sixty-seven acres called Strawberry Hill that sat on the opposite shore of College Creek, where the cemetery and medical center are currently located, for a total of almost two hundred acres.

One of the smaller parcels acquired by the academy was the poor and rather rough neighborhood that the locals still refer to as "Hell's Point," a small, eight-acre parcel next to the academy, near City Dock. All individual acquisitions, large and small, had to be approved by Congress, and the request for Hell's Point was approved with a stroke of a congressional pen in March 1899, based largely on the vivid description by the officer in charge of buildings and grounds:

> *It does not contain any buildings of much value, but several noisy rum shops, and other houses of questionable character, which are a menace to*

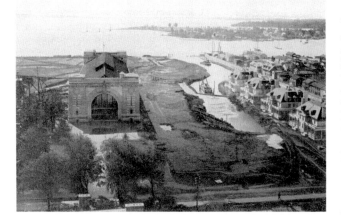

This 1904 postcard shows how the academy made more land by dredging the Severn River over more than forty years. "You could hear the noise all night long" across the river in Eastport, said longtime Eastport resident Melvin Howard. *Courtesy of the Chesapeake Bay Maritime Museum.*

the Naval Academy. It [also] contains one large oyster packing house… There are always oyster shells piled up and spread about on this property… creating a very unpleasant odor, which is wafted by the prevailing wind into the Cadet and Officer's Quarters. The oyster packing employs a number of people of both sexes, not of the highest character, whose language is loud, boisterous, and very unsavory, and can be heard over that part of the Academy where the new Cadet quarters are to be located.[200]

Congress approved the acquisition, and the people of Hell's Point moved into the fabric of downtown Annapolis.

The Naval Academy continued to grow and soon ran out of space again, this time with no adjacent land available in the city. So, over the course of twenty-six years, forty-two acres of land were created for the academy by scooping muck and fill out of the Severn River and waters that surround the academy until it was terra firma. Another twenty-four acres were created in 1941–42. This engineered land provided space for buildings' expansion and for the athletic fields that ring the academy grounds today.[201]

Not only did the expansion cause the displacement of some of the poorest Annapolitans, but it also forced some local businesses to close or relocate to Baltimore. For most of Annapolis, however, there was pride in hosting the academy. That pride was mutual, as Elmer Jackson Jr. noted in his book *Annapolis*, written in 1936:

Pride at being an Annapolis man swells in the breasts of the naval officer. They never forget that Annapolis is unique in scenic beauty, romantic associations, and the irresistible emotional force revolving around tradition.

Midshipmen training on earlier versions of yard patrols (YPs), 1939. *Courtesy of the United States Naval Academy Archives.*

As with many romances, there were challenges. Most of the heartache would come from the midshipmen—young men trying to find their way through the growing pains of becoming an officer and a gentleman.

THE NAVY'S HOMETOWN

The military pageantry of the academy has always made it the darling of Annapolis society. Balls, concerts and parties featuring or hosted by the academy's officers and midshipmen were popular and well attended, as was enthusiastically reported in the *Maryland Gazette* on December 28, 1854:

> *The senior midshipmen at the Naval Academy gave a complimentary soiree to the citizens of Annapolis, on Friday evening last. The room was handsomely decorated with flags of various nations…the beautiful women and brave men were assembled, formed a* tout ensemble *of a most bewitching, beautiful kind. The affair was admirably arranged, and reflected great credit upon the polite gentlemen who presided over it; and doubtless, they feel well rewarded by the unmistakable happiness evinced by their guests.*

The biggest fans of the academy's social events were the local young women who cleared their calendars for the important events of dances and football games. Midshipmen also brought in "drags," dates from out of town, to attend the formal dances, and these women stayed at a local inn or with families they or the midshipmen knew. Marriages between young Annapolis women and men at the academy were inevitable from the very beginning.

The academy's first superintendent, Commander Franklin Buchanan, married Anne Catherine Lloyd, the daughter of one of Annapolis's most prominent families, and the first assistant instructor in mathematics, Passed Midshipman Samuel L. Marcy (a rank equal to the modern-day ensign), married Eliza Humphreys, the daughter of the president of St. John's College.[202] There are no official data on the number of marriages of local women and midshipmen, but for as long as anyone alive can recall, the chapel has been booked solid with back-to-back weddings the weekend that follows graduation. As one longtime resident said, "It is difficult to name a longstanding Annapolis family without some Navy connection through marriage."

A cloud fell over the Annapolis–Naval Academy romance in 1918, and fun in Annapolis came to a grinding halt for the midshipmen. The strict Secretary of the Navy Josephus B. Daniels declared Annapolis a "dry zone" and mandated that all liquor be removed within a five-mile radius of the academy. The city was turned upside down as it scrambled to meet a three-week deadline, and bars faced a hefty fine of $1,000 for any infraction. Annapolis was not alone. The five-mile dry zone was instituted around several other U.S. military bases, including Quantico Marine Corps Base in Virginia.[203]

The most popular unofficial recreational sport at the academy was, and likely always will be, pursuing the opposite sex. Midshipmen and their "drags" on the bay in 1943. *Courtesy of the Chesapeake Bay Maritime Museum.*

Secretary Daniels was already notorious for coffee's new nickname, "cup of Joe." Four years before wreaking havoc on downtown Annapolis bars and hotels, Secretary Daniels had banned alcohol from all navy ships, killing the officers' beloved wine mess. Overnight, coffee was the strongest drink available onboard navy ships, and any U.S. Navy or Marine Corps officer on a ship who wanted something stronger than water to drink asked for a "cup of Joe," dubiously honoring the secretary.

In happier times, Superintendent Rear Admiral Henry B. Wilson tightened the bond between the academy and its hometown with a significant public relations program in 1922. America loved its new automobiles and had become a nation of tourists. Wilson made the academy a tourist destination, with well-orchestrated tours of the academy, giving Annapolis a firm foundation in the tourist trade that continues today.

MIDSHIPMEN ON THE WATER

A blistering comment appeared in the local *Maryland Gazette* in 1949 after news broke that some midshipmen due to graduate did not have the expertise necessary to sail small craft:

> *If a future Captain of a 45,000 ton battleship or gigantic aircraft carrier is to command it to the best of his ability, he ought to know how to handle a 12 foot tempest dinghy. Handling a small boat in Annapolis' tides and currents gets the middies used to the elements when they rise to command warships.*[204]

The concern was not without foundation. Almost one hundred years before that newspaper item appeared, midshipmen studied on some of the greatest ships in sailing history. Aside from the *Constitution*, which remains the oldest commissioned ship in the United States Navy today, there was the *Constellation*, the first commissioned ship in the United States Navy in 1799, which served in several wars, and the esteemed sailing vessel the *America*, the first practice vessel originally designed as a yacht.

For the first six years of the academy, midshipmen spent an impressive two to three consecutive years of their educations at sea. In 1851, time at sea for the midshipmen was limited to just summer cruises to keep their classroom educations uninterrupted. That same year, the midshipmen were introduced to being quartered on a steamship for the summer cruise.[205] The last summer cruise on a sailing ship was in 1909, on the sloop *Hartford*, a veteran of the Civil War.

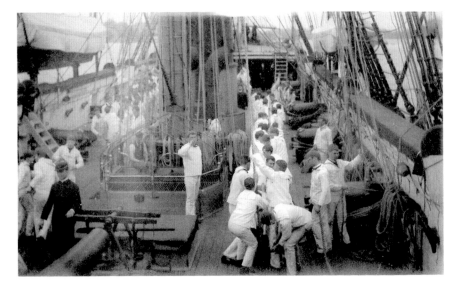

Midshipmen on the annual summer cruise aboard the USS *Wyoming* in 1890. *Courtesy of the United States Naval Academy Archives.*

The navy's areas of warfare expertise moved from nineteenth-century sailing ships to steam-powered warships and then submarines and, later, aviation. Aviation arrived in Annapolis in 1911, with three navy planes at the navy's first aerodrome, across from the academy, on Greenbury Point.

The academy was the site chosen for the first attempt to launch an aircraft by compressed-air catapult in 1912, but it did not go well. The plane took off from the academy's Santee Dock, where Spa Creek and the Severn River meet, and stalled halfway down the wharf, only to splash into the Severn. Luckily, pilot and plane were not hurt and both later went on to successfully launch off a barge in the Anacostia River, just outside of Washington, D.C.[206]

Midshipmen were introduced to the navy's first seaplane, the Curtiss C-1, at the same time as Secretary of the Navy Josephus Daniels and the navy's young Assistant Secretary Franklin D. Roosevelt, who came to Annapolis for the big event. The two VIPs went up in the navy's first flying boat and then permanently moved the Naval Air Station from across the Severn River to Pensacola, Florida.[207]

Sailing as an academic requirement took a backseat when steam power appeared in the early part of the twentieth century. The academy's square riggers disappeared one at a time, and the few that were left were considered beloved relics for occasional training or drill exercises. Sailing evolved into an intramural sport in the very early 1900s, with the academy's first

recreational fleets made up of catboats and small knockabouts, the latter designed by Annapolis boat builder Charles Owens.[208]

Charles Owens was having a ball. Every so often, he liked to take a break from work and sail his twenty-six-foot sloop, which he designed, out onto the Severn River and sail circles around the midshipmen in their half-raters, twenty-foot carvel-planked sailboats. It wasn't exactly kind, but it sure was fun. It was a harmless lark, and getting out on the water was the best way to relax from his boat-building company.

Owens's life was not always so easygoing. After losing his wife to the Spanish flu epidemic in 1918, Owens was left to raise his five children alone in Detroit. Disowned for marrying an Irish woman, he had no family to turn to, so he decided to leave his lucrative business career with Westinghouse, build a boat and sail it to Annapolis with his sons.

Once settled there, Owens turned out small sailboats from his basement. People started buying the boats, and he opened his own boatyard on Spa Creek in Annapolis, one of about eleven on the creek at the time. As popular as his knockabouts were, no one loved sailing them more than Owens.

Watching from the shore one day was the Naval Academy sailing coach, who later contacted Owens and asked him if he was interested in building boats for the academy. In 1928, Owens received a contract to build six Naval Academy knockabouts and then another fourteen after that, all of which were used as basic trainers for midshipmen for nearly forty years.

By the 1930s, there was a revival of sailing at the academy that coincided with the beginnings of sailing as a national pastime. Superintendent at the time Rear Admiral Thomas C. Hart was certain that if midshipmen were encouraged to sail, they would in turn learn to love and understand the sea better. It was a sure bet.

By 1937, sailing had become the academy's largest extracurricular activity, with 250 members in the new Midshipmen Boat Club. That same year, the academy received a sizeable gift from a well-to-do foreigner, a former Russian naval officer and inventor, Vadim S. Makaroff. In a tradition of gifting that continues today, the wealthy man presented the academy with a sailing yacht, the *Vamarie*, a seventy-two foot, mahogany-hulled, staysail ketch—luxurious and very fast.[209]

Midshipman Robert McNitt, vice commodore of the Midshipmen Boat Club at the time, was dazzled by the *Vamarie* and worked tirelessly to convince the academy's administration to enter her, with an academy crew, in the annual Bermuda ocean race. After a few Chesapeake races with the *Vamarie* under his belt, McNitt got his wish. The following summer, the *Vamarie* finished twenty-ninth out of forty-four in the 1938 Bermuda ocean

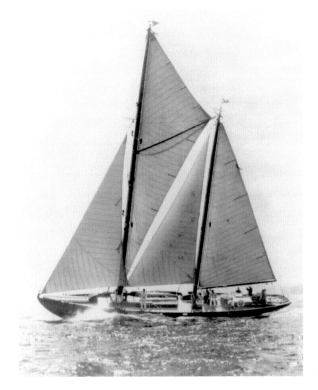

A gift to the naval academy, the *Vamarie* under sail. Circa 1937. *Courtesy of the United States Naval Academy Archives.*

race, a respectable finish for the inexperienced crew considering a rigging disaster left the boat's mainsail useless for most of the race. The academy has participated in every biannual Bermuda race since 1938. Ocean racing had come to the academy, and it stayed for good.

Following the *Vamarie*, the offshore fleet was composed of Luder yawls, which were ultimately replaced by forty-four-foot sloops designed by the Naval Academy. In addition to racing, the fleet of "Navy 44s" is used to train midshipmen on seamanship and navigation.

Because of their success in offshore racing, and with the help of generous alumni, the Naval Academy fleet also has a number of "donation boats," usually well-built, "well-founded" and fast racing boats given to the school for use in training and racing. The Naval Academy and Annapolis share their love for yachting openly by cosponsoring, beginning in 1947, the first Annapolis–Newport race, continuing the tradition of goodwill and cooperation between the academy and its hometown both on and off the water, including racing, coaching and, of course, donating beautiful yachts.[210]

Conclusion

On a perfect late September day during Annapolis's prime sailing season, a steady ten-knot northeast wind drives the thirty-two-foot sailboat *Plein Air* past Greenbury Point, the location of the city's first settlement, Providence, and where colonial Annapolis once manned a fort to help defend the city from the British.[211]

"Four knots...four point eight...*five knots!*" shouts Frank Thorp, oblivious to the conversation going on around him. A wide smile covers his face, and his wife, Tammy, leaning against the aft rail, returns the smile. "It just doesn't get any better than this," he says to no one in particular on that sunny afternoon, and for a moment you can see the face of the boy who had grown up in Eastport—a true son of Annapolis.

Frank tacks the boat easily in front of Santee Wharf at the United States Naval Academy, where, following service in three wars, the great sailing ships *Constellation* and *Constitution* once moored as training ships for the midshipmen. The Naval Academy has produced many great leaders of our nation, such as Admiral Chester Nimitz and President Jimmy Carter, and men and women who served their country selflessly, like Admiral Frank Thorp Jr., USNA class of 1981.

With sails down and the motor now pushing the boat back toward its slip on Spa Creek, the *Plein Air* glides past the Chart House Restaurant, which occupies the original covered boat shed that dates back to World War II, when it was built to house production of an impressive 140 World War II warships by the Annapolis Yacht Yard. Trumpy & Sons would follow AYY on the property, producing its world-renowned yachts.

With still fifteen minutes remaining before the next opening of the Spa Creek Bridge, Frank steers the boat past the downtown wharf, where steamships like the *Emma Giles* once loaded passengers bound for the Eastern

Shore or Baltimore, and falls into the steady parade of boats puttering down City Dock. Once packed with working boats lying gunwale to gunwale against the bulkhead, today it is filled with pleasure boats and is affectionately known as Ego Alley, a place to see and be seen.

The Market House at the end of City Dock is quiet, unrecognizable as a bustling center of commerce for over two hundred years. Tourists congregate in front of the Market House at water's edge, where the city's Fish Market once sat so that watermen could hand their catch straight to the merchants in their market stalls.

Frank is too young to remember the Fish Market, but he did buy eels at the Market House for crab bait—and he remembers the pungent smell that surrounded City Dock. Like hundreds of other children in Annapolis, white or black, Frank, his five sisters and his grammar school buddies crabbed the shallow waters surrounding Annapolis. It's a prettier and better smelling City Dock today, without the crumbling bulkheads, boatyard debris and hundreds of fishing boats packed in the small area, but it's not any quieter. The sounds of men hawking their seafood and the shouts from working boatyards and watermen have been replaced with music from outdoor restaurants and the loud engines of modern "muscle" boats trying to impress the crowd of tourists.

The *Plein Air* exits Ego Alley and continues past the Annapolis Yacht Club, which stands in the same place as when it was built as the Severn Boat Club in 1866. This is where Frank discovered his love of sailing in the 1960s, learning the fundamentals at the club where his father, Frank Sr., was one of the original members. Almost at the edges of his memory, Frank recalls the boat that his father and mother owned, a three-quarters-scale replica of Joshua Slocum's famous boat the *Spray*, the boat that anchored all of the family's recreational activity.

With the Spa Creek Bridge raised, the *Plein Air* passes underneath, directly in front of the spot where yachtsman Arnie Gay's boatyard once stood—the same place where, two hundred years before, General Lafayette and his troops encamped before continuing on to Virginia to join General Washington.

Over the course of his career as a naval officer, Frank has had to pick up and move numerous times to meet the "needs of the navy." With retirement on the horizon, Frank and Tammy looked for a place to live on their terms, not the navy's, and it was an easy choice to return to Annapolis. Frank reflected on what pulled him back to his hometown. "You know that phrase 'you can never go home again'? That doesn't apply for me. Everyone in my family who comes back feels the same strong connection."

There is something about Annapolis, the combination of a small waterfront town and a capital city where, whether you are an influential person or not,

Right: Young Frank Thorp on Spa Creek, 1969. *Courtesy of Frank and Tammy Thorp.*

Below: Admiral and Mrs. Frank Thorp (Tammy Kupperman) at the christening of the aircraft carrier USS *George H.W. Bush* in Norfolk, 2009. *Courtesy of the Thorp family.*

you can be an Annapolitan. The water and the city's maritime heritage are great equalizers.

Frank and Tammy had considered moving back to Eastport, long remembered as the more modest part of Annapolis, and he let out a laugh, recalling their initial search for a home. "The houses that were the most expensive were in an area I wasn't allowed to go into as a kid because it was considered too rough." Instead of Eastport, the Thorps purchased an eighteenth-century home downtown, just two blocks from Shipwright Street, where one of the many Annapolis boatyards built and repaired schooners for Annapolis's eighteenth-century trade. While his childhood home on Spa Creek has been replaced with town houses, Frank did manage to get his old Eastport phone number. "After 28 years of constantly moving, my sisters can now call me without having to look up the number."

Annapolis's maritime tradition thrives in the people who live here, the stewards of their history. Even today, the people of Annapolis embody their heritage. Whether crewing on a sailboat during one of the many races in the harbor or bellying up to a bar in front of a plate of fresh, raw oysters, or touring the grounds of the Naval Academy, everyone is affected by the far-reaching influence of Annapolis's maritime history. There are unbreakable bonds that have survived the political, economic and social challenges of the centuries since the colonists first settled in a wilderness called Providence. These bonds have survived because Annapolis maritime history is, after all, a story about the people.

Notes

Introduction

1. John R. Wennersten, *The Oyster Wars of the Chesapeake Bay* (Centreville, MD: Tidewater Publishers, 1981), 39.
2. Patricia Blick, chief preservationist for Annapolis, personal correspondence with author, February 23, 2009.
3. James C. Bradford, "Naval History," in *Anne Arundel County, Maryland Bicentennial History, 1649–1877* (Annapolis, MD: Anne Arundel County and Annapolis Bicentennial Committee, 1977), 26.
4. City Dock is the body of water that is surrounded on three sides by wharves, piers and bulkheads.

Chapter One

5. The author refers to the area as City Dock after Annapolis was established as the capital of Maryland in 1695.
6. Anthony D. Lindauer, *From Paths to Plats: The Development of Annapolis 1651 to 1718* (Annapolis: Maryland State Archives and Maryland Historical Trust, 1997), 4.
7. Nancy T. Baker, "Chandlery in Annapolis," *Chronicle of the Early American Industries Association, Inc.* 35, no. 4 (December 1982): 61.
8. Lindauer, *Paths to Plats*, 9; cites Maryland State Archives 7, 351, 460, 465.
9. Shirley V. Baltz, *The Quays of the City: Account of the Bustling Eighteenth-Century Port of Annapolis* (Annapolis, MD: Liberty Tree, 1975), 1.

10. Paul Shackel, *Personal Discipline and Material Culture: An Archeology of Annapolis, Maryland, 1695–1870* (N.p.: University of Tennessee Press, 1993), 59.

11. John Wing, *"Bound By God For Merryland": The Constant Friendship* (Annapolis: Maryland State Archives and Maryland Historical Trust, 1999), 2; cites V.J. Wyckoff, economic historian, St. John's College, 1924–1939.

12. Daniel Higman, "The Fields of Fortune in Colonial Maryland," *Anne Arundel County History Notes* (Summer 2008): 3.

13. Baker, "Chandlery in Annapolis, 62.

14. Robert Barnes, *Colonial Families of Anne Arundel County* (Westminster: Maryland Family Lines Publications, 1996), 157.

15. Baker, "Chandlery in Annapolis," 62.

16. Ibid.; cites *Maryland Gazette*, December 3,1728; February 18, 1729; and December 8, 1730.

17. "In Harbor," *Maryland Gazette*, May 1949, tercentenary edition, 8A.

18. *Maryland Gazette*, October 19, 1748.

19. "Historic Annapolis, Inc., Fact Sheets for Interpreters on the Preservation, Restoration and History of Annapolis," 1987, 5–8, 9. Hereafter cited as HAI Fact Sheets.

20. Baltz, *Quays of the City*, 23; cites Calvert Papers #1302–MSS, Maryland Historical Society, Baltimore.

21. Wennersten, *Oyster Wars*, 8.

22. George Schaun, "Maritime History," in *Anne Arundel County Maryland Bicentennial History, 1649–1877* (Annapolis, MD: Anne Arundel County and Annapolis Bicentennial Committee, 1977), 86.

23. Baker, "Chandlery in Annapolis," 64.

24. Ibid., 65.

25. Ibid.; cites *Maryland Gazette*, May 21, 1752; and June 18, 1752.

26. Vaughan W. Brown, *Shipping in the Port of Annapolis, 1748–1775* (Annapolis, MD: United States Naval Institute, 1965), 13.

27. Arthur Pierce Middleton, *Tobacco Coast: A Maritime History of Chesapeake Bay in the Colonial Era* (Newport News, VA: Mariners' Museum, 1953), 152.

28. Ibid., 169; cites *Maryland Gazette*, July 9, 1767.

29. Brown, *Shipping in the Port*, 22.

30. HAI Fact Sheets, 3–20.

31. Ibid., 4–12.

32. Baker, "Chandlery in Annapolis," 65.

33. "Navigation Act Advanced Freedom," *Maryland Gazette*, May 1949, tercentenary edition, C1.

34. HAI Fact Sheets, 4–12.

35. Brown, *Shipping in the Port*, 7.

36. Jack Sweetman, *U.S. Naval Academy* (Annapolis: Naval Institute Press, 1977), 23.

37. Baltz, *Quays of the City*, 22; cites "Diary of a French Traveler, 1765," *American Historical Review* 27, 70.

38. Baltz, *Quays of the City*, 22; cites *The Charter and Bye-Laws of Annapolis* (N.p.: Anne Catherine Green, 1769), located in the Maryland Historical Society Library.

39. Baltz, *Quays of the City*, 24.

40. Lee Merrill, urban designer, City of Annapolis, untitled essay in Marion E. Warren, *An Annapolis Portrait: The Train's Done and Gone* (Annapolis, MD: 1976), 31.

41. Ginger Doyel, *Annapolis Vignettes* (Centerville, MD: Tidewater Publishers, Maryland, 2005), 59; cites Don Riley, "I Remember…Sights and Smells of Old Annapolis Market," *Sunday Sun Magazine* (1959).

42. Clarence M. and Evangeline K. White, *The Years Between: A Chronicle of Annapolis, Maryland 1800–1900* (New York: Exposition Press, 1957), 32.

43. Ginger Doyel, *Gone to Market: The Annapolis Market House 1698–2005* (Annapolis, MD: City of Annapolis, 2005), 15; cites *Maryland Gazette*, February 7, 1754.

44. Hildegard Hawthorne, "Rambles in Old College Towns," in Mame and Marion Warren, *Maryland Time Exposures 1840–1940* (Baltimore, MD: Johns Hopkins University Press, 1984), 187–88.

45. Mame and Marion Warren, *Then Again…: Annapolis 1900–1965* (Annapolis, MD: Time Exposures Ltd., 1990).

CHAPTER TWO

46. Kerry R. Muse, "Anne Arundel's Seafood Industry," in *Maryland Bicentennial History 1649–1877* (Annapolis, MD: Anne Arundel County and Annapolis Bicentennial Committee, 1975), 75.

47. "Diamondback Terrapin—A Food for Kings and Marylanders," *Maryland Gazette*, May 1949, tercentenary edition, 18D.

48. Muse, "Anne Arundel's Seafood," 74.

49. Middleton, *Tobacco Coast*, 68.

50. www.fishcooking.about.com and www.foodandsocietyfellows.org/publications.cfm?refID=79012, accessed Mach 7, 2009.

51. Middleton, *Tobacco Coast*, 69; cites *Virginia Magazine of History and Biography* 14, 374.

52. Ibid., 225.

53. Baltz, *Quays of the City*, 9; cites Ramsey File, Box 35, folder 6, Delaware Historical Society, Wilmington.

54. Wennersten, *Oyster Wars*, 6.

55. William W. Warner, *Beautiful Swimmers: Watermen, Crabs and the Chesapeake Bay* (Boston: Atlantic Monthly Press, 1976), 63; cites town records of Colchester, Essex.

56. Vince Leggett, Blacks of the Chesapeake Foundation, personal correspondence with author, March 12, 2009.

57. HAI Fact Sheets, 3–20.

58. Ginger Doyel, *Over the Bridge—Eastport* (Annapolis, MD: Annapolis Maritime Museum, 2008), 125.

59. Fred Hecklinger (local historian), personal correspondence with author, March 9, 2009.

60. M.V. Brewington, *Chesapeake Bay Bugeyes* (Newport News, VA: Mariners' Museum, 1941), 3.

61. Wennersten, *Oyster Wars*, 5.

62. Richard "Jud" Henderson, *Chesapeake Sails: History of Yachting on the Bay* (Centreville, MD: Tidewater Publishers, 1999), 87; quotes designer/historian Eric Steinlein.

63. Brewington, *Chesapeake Bay Bugeyes*, 3.

64. Wennersten, *Oyster Wars*, 99; cites M.V. Brewington and author's personal interview with Fred Hecklinger, February 13, 2009.

65. Martha C. Weber, *Maryland by Way of Sailing Ships* (Cortez, CO: Masa Verde Press, 1984), 26.

66. George Barrie Jr. and Robert Barrie, *Cruises Mainly in the Bay of the Chesapeake* (Bryn Mawr, PA: Franklin Press, 1909), 130.

67. Weber, *Maryland by Way of Sailing*, 26.

68. Anne McNulty, "Those Vanishing Skipjacks," *What's Up? Annapolis Magazine* (January 2009): 64.

69. Wennersten, *Oyster Wars*, 48.

70. Ibid., 14.

71. Ibid., 137; cites Caswell Grave, *History of the Oyster in Maryland* (Baltimore, MD: 1912).

72. Ibid., 40.

73. Maryland Department of Natural Resources, ch. 24, Acts of 1820.

74. Wennersten, *Oyster Wars*, 89.

75. Warmer, *Beautiful Swimmers*, 72–73.

76. *Maryland Gazette*, March 3, 1896.

77. Larry Simms, Maryland Watermen Association, personal interview with author, March 16, 2009.

78. Wennersten, *Oyster Wars*; cites "Poach Oysters," *Harper's*, March 4, 1884.

79. Wennersten, *Oyster Wars*, 36.

80. Ibid.; cites Davidson court testimony, 1881.

81. Wennersten, *Oyster Wars*, 43.

82. Ibid.

83. Ibid., 50.

84. Sweetman, *Naval Academy*, 74; cites James D. Horan, ed., *Shenandoah: Memoirs of Lieutenant Commanding James I. Waddell* (New York: Crown Publishers, Inc., 1960).

85. Wennersten, *Oyster Wars*, 77.

86. Ibid., 74, 16.

87. Ibid., 56.

88. Ibid., 35 quotes Samuel T. Sewell, waterman.

89. Ibid., 58.

90. Ibid., 62.

91. Ibid., 63.

92. *Baltimore Sun*, 1948, located in the Anne Arundel County Historical Society (hereafter cited as AACHS), oyster topic file, no headline or specific date available.

93. Russo, correspondence, Sanborn City Map, 1897.

94. William Calderhead, "African Americans," in *Anne Arundel County Maryland Bicentennial History 1649–1877* (Annapolis, MD: Anne Arundel County and Annapolis Bicentennial Committee, 1975).

95. *Baltimore Sun Magazine*, 1976, AACHS, oyster topic file, March, 1976.

96. *Annapolis Capitol*, March 26, 1986, quotes Mark Abraham, McNasby general manager.

97. Maryland Department of Natural Resources, ch. 314, Acts of 1886.

98. Wennersten, *Oyster Wars*, 26.

99. Werner, *Beautiful Swimmers*, 85.

100. Ibid., 77.

101. Ibid., 83.

102. White, *The Years*, 60.

103. Russo, correspondence; cites Maryland Bylaws and ordinances, 1881–97, 100; and personal correspondence with local historian Jane McWilliams, February 2009, citing 1891/02/09—Bylaw re: Market House. Repeals and reenacts section 11 of article 18 and ANNAPOLIS MAYOR AND ALDERMEN (Bylaws and Ordinances) 1881–1897 [MSA M51-3], p. 100.

104. White, *The Years*, 58.

105. Doyel, *Eastport*, 261.

106. Warner, *Beautiful Swimmers*, xii.

107. Maryland State Archives, http://www.msa.md.gov/msa/mdmanual/01glance/html/symbols/fish.html, accessed December, 7, 2008.

108. Chesapeake Bay Program, "Bay Field Guide," http://www.chesapeakebay.net/bfg_striped_bass.aspx, accessed December 7, 2008.

109. Maryland State Archives, http://www.msa.md.gov/msa/mdmanual/01glance/html/symbols/fish.html, accessed December 8, 2009.

110. Maryland Department of Natural Resources, http://www.dnr.state.md.us/fisheries/fishfacts/menhaden.asp, accessed March 12, 2008.

111. Maryland Department of Natural Resources, http://www.dnr.state.md.us/mydnr/askanexpert/softshell_clam.asp, accessed December 7, 2008.

112. Capital News Service, "Water's Appeal Keep Oystermen Coming Back," posted March 16, 2008.

CHAPTER THREE

113. Alexander Crosby Brown, *Steam Packets on the Chesapeake: A History of the Old Bay Line Since 1840* (Centreville, MD: Tidewater Publishers, 1961), 1.

114. *Maryland Gazette*, May, 1949, tercentenary edition, photo caption 11.

115. Warner, *Beautiful Swimmers*, 70.

116. Pete Lesher, curator, Chesapeake Bay Maritime Museum, personal correspondence with author, March 12, 2009.

117. Henderson, *Chesapeake Sailing*, 3; cites Thomas Fleming, editor of *Rudder Magazine*, 1905.

118. *Maryland Gazette*, May 1949, tercentenary edition.

119. Weber, *Maryland by Way of Sailing Ships*, 26.

120. Baltz, *Quays of the City*, 2; cites John C. Fitzpatrick, ed., *Diaries of George Washington* (Boston: 1925).

121. *Maryland Gazette*, March 6, 1782; April 22, 1762; and April 14, 1763.

122. *Maryland Gazette*, February 17, 1747.

123. Russo, correspondence, March 4, 2009.

124. *Maryland Gazette*, December 16, 1791; and June 27, 1793.

125. Lesher, correspondence, March 12, 2009.

126. Hecklinger, correspondence, March 6, 2009.

127. John A. Hain, *Side Wheel Steamers of the Chesapeake Bay, 1800–1947* (Glen Burnie, MD: Glendale Press, 1947).

128. Brown, *Steam Packets*; cites J.T Scharf, *Chronicles of Baltimore* (N.p.: 1847), 505–06.

129. Hain, *Side Wheel Steamers*, 50.

130. *Guide to Cruising Chesapeake Bay* (N.p.: Chesapeake Bay Communications, Inc., 2004), 24.

131. *Evening Capital,* June 22, 1887.

132. Ibid.; Henderson, *Chesapeake Sailing*, 27.

133. Winans, discussion, March 13, 2009.

134. Hyman Rudolf, "Lighthouse—Newsletter," *Chesapeake Bay Magazine* (December 1991).

135. Annapolis harbormaster's office, personal interview with author, February 25, 2009.

136. Henderson, *Chesapeake Sailing*; cites historian M.W. Brewington.

137. Ann Offutt Boyden, "The Bugeye 'Richard J. Vetra' and Other Bay Craft: A Reminiscence," August 1995, Chesapeake Bay Museum. No surname provided by Ms. Ann Offutt Boyden for the boat's original owner or the ship's carpenter.

138. Hecklinger, discussion, March 6, 2009.

139. "Bone in her teeth" refers to when a boat is sailing under full sail and cuts through the water, tossing up spray.

140. Henderson, *Chesapeake Sailing*, 3.

141. Brewington, *Chesapeake Bay Bugeyes*, 79.

142. White, *The Years Between*, 66.

143. Ibid.

144. Ibid., 67.

145. Ibid.; Henderson, *Chesapeake Sailing*, 17.

146. Carelton Mitchell, "Bay, River Play Great Parts in Life of Area," *Maryland Gazette*, May, 1949, tercentenary edition, 3D.

147. Henderson, *Chesapeake Sailing*, 42.

148. Ibid., 136.

149. "Sails Dominate Skyline But City Is Also Haven For Many Power Boats," *Maryland Gazette*, May 1949, tercentenary edition, 3D.

150. Ann Dermody, "It Was A Club of Their Own," *BoatU.S. Magazine* (March 2009): 26.

151. Remarks made to the Annapolis Maritime Museum membership by Dr. Stuart Walker, local sailing historian, January 23, 2009.

152. Molly Winans, editor, *SpinSheet*, personal interview with author, February 12, 2009.

153. Hecklinger, discussion, March 6, 2009.

154. Henderson, *Chesapeake Sailing*, 48.

155. Winans, discussion, March 13, 2009.

156. Captain Richards Miller USN (ret.), "The Last Days of America" (unpublished paper, Annapolis, May 2, 2007).

157. Ibid.

158. James Cheever, senior curator, U.S. Naval Academy Museum, personal correspondence with author, March 13, 2009.

159. Hecklinger, discussion, February 12, 2009.

160. Miller, "The Last Days of America," 2.

161. Donald Trumpy and Sigrid Trumpy, personal interviews with author, 2008.

Chapter Four

162. Al Luckenbach, *Providence 1649* (Annapolis: Maryland State Archives and Maryland Historical Trust, 1999), Index, 25; cites Colman Hall Clayton, *Narratives of Early Maryland: 1933–1684* (New York: Charles Schribner & Sons, 1910), 163.

163. "Battle of Severn Was Fought At Horn Point," *Maryland Gazette*, May 1949, tercentenary edition, 19-C.

164. A derisive name for the supporters of Parliament during the English Civil War, referring to the Puritans' short haircuts as compared to the fashionable long-haired wigs worn by King Charles I Cavaliers. The governor was apparently quite angry—there are reports of him referring to the colony as a "nest of ungrateful serpents."

165. The number of Governor Stone's troops varies in historic accounts from 120 or 130 to 150.

166. J. Wirt Randall, Historic Annapolis, transcript of address delivered in Baltimore on July 28, 1911.

167. There are two recorded accounts of Stewart. One has him as a Loyalist complicit in trying to hide the tea and the other has him as an innocent, duped by two British sympathizers to bring their tea to Annapolis.

168. Land was created from dredging the Severn in the nineteenth century for expansion of the Naval Academy.

169. Robert Tinder, "'A Formidable Enemy in Our Bay': Maryland and the British Invasion of the Chesapeake, 1780–1781," *Maryland Historical Magazine* 103, no. 2, p. 166, cites Robert Puriance, *A Narrative of Events Which Occurred in Baltimore Town During the Revolutionary War* (Baltimore, MD: Joseph Robinson, 1849), 92, 224–26.

170. Tinder, "Formidable Enemy," 179–80, cites Louis Gottschalk, *Lafayette and the Close of the American Revolution* (Chicago: University of Chicago Press, 1965), 206–207.

171. Baltz, *Quays of the City*, 29; cites "Letters of Lafayette," *Virginia Historical Magazine* 5, p. 375.

172. First name is not available. "Old Fort Severn, A Landmark at the Naval Academy to be Repaired," *New York Times*, July 2, 1892.

173. Elmer Jackson, Jr., *Annapolis: Three Centuries of Glamour*, The Capital-Gazette Press, Annapolis, 1936, 71.

174. Sweetman, *Naval Academy*, 4-5; cites Park Benjamin, *The United States Naval Academy* (New York: G.P. Gutman's Sons, 1900), 136.

175. Sweetman, *Naval Academy*, 16.

176. Sweetman, *Naval Academy*, 10; cites Benjamin, *Naval Academy*, 143.

177. Sweetman, *Naval Academy*, 8; cites *Naval Regulations* (1802), 18.

178. Sweetman, *Naval Academy*, 3, cites Harrison Hayford, ed., *The Somers Mutiny Affair*; Frederic van de Water, *The Captain Called it Mutiny*; and Samuel Eliot Morison, *"Old Bruin": Commodore Matthew Calbraith Perry.*

179. Ibid., 3; cites three sources for the story of the Somers mutiny: Harrison Hayford, ed., *The Somers Mutiny Affair* (Englewood Cliffs, NJ: Prentice-Hall Inc., 1960); Frederic van de Water, *The Captain Called it Mutiny* New York, Ives Washburn, 1954); and Samuel Eliot Morison, *"Old Bruin": Commodore Matthew Calbraith Perry*, (Boston, Little, Brown & Co., 1959).

180. Sweetman, *Naval Academy*, 97; cites Benjamin, *Naval Academy*, 136.

181. Sweetman, *Naval Academy*, 3; cites Hayford, *Somers Mutiny Affairs*.

182. Sweetman, *Naval Academy*, 23; cites Soley, *National Intelligencer*, 66.

183. Sweetman, *Naval Academy*, 60; cites Blake's letter to Secretary of the Navy Gideon Welles, April 2, 1861.

184. Sweetman, *Naval Academy*, 59; cites Robley D. Evans, *A Sailor's Log: Recollections of Forty Years of Naval Life* (New York: D. Appleton & Co., 1901), 46–47.

185. Sweetman, *Naval Academy*, 62.

186. Ibid., 63.

187. Ibid.; cites Rear Admiral Charles E. Clark, *My Fifty Years in the Navy* (Boston: Little, Brown & Co., 1917), 34–35.

188. Sweetman, *Naval Academy*, 64–65; cites Park Benjamin, *Shakings, by a Member of the Class of 1867* (Boston: Lee & Shepard, 1868), 240.

189. Sweetman, *Naval Academy*, 83.

190. Ibid., 97.

191. Graduates included reservists, as well as midshipmen.

192. Sweetman, *Naval Academy*, 197–98.

193. Chance Marine Construction did not finish the fourth subchaser, per local historian Mike F. Miron.

194. Captain Richards Miller, US Navy (ret.), "Sup Ships Annapolis," *Naval History* (May/June 1999): 51.

195. Transcript of Mike F. Miron interview with Joe Alton, April 26, 1999.

196. Ibid.

197. Henderson, *Chesapeake Sailing*, 41; cites John Wilbur, *The U.S, Coast Guard's Coastal Picket Patrol* (N.p.: 1991), 7.

198. Henderson, *Chesapeake Sailing*, 41; cites Corsair fleet researcher John Wilbur. The skipper of the *Tradition* was Eugene Topane.

199. The USS *Santee* was the USNA's station ship until it sank at its wharf on April 2, 1912. The wreck of the *Santee* was raised and hauled to Boston, where it was burned for its metals. The name Santee continues to be used for the boat basin at the Naval Academy, which is located quite near where this old wharf stood in the nineteenth century. Cheever, discussion, April 10, 2009.

200. National Archives, Record Group 405, letterpress book from the U.S. Naval Academy Department of Buildings and Ground, vol. 445, 260.

201. "63 Acres Of Academy Is Reclaimed," *Maryland Gazette*, May 1949, tercentenary edition, E1; and James Cheevers, senior curator, U.S. Naval Academy Museum, "U.S. Academy Buildings and Grounds" document, n.d.

202. Sweetman, *Naval Academy*, 13, 30; cites Charles Lee Lewis, "Description of the U.S. Naval Academy," *USNIP* (October 1935): 74–76.

203. *Annapolis Advertiser*, March 4, 1918, 1.

204. *Maryland Gazette*, May 1949, tercentenary edition.

205. Sweetman, *Naval Academy*, 42; cites Edward P. Lull, *Description and History of the Naval Academy from Its Origin to the Present Time* (N.p.: 1869), 15.

206. Sweetman, *Naval Academy*, 166; cites, Rear Admiral George van Deurs, USN (Ret.), *Wings for the Fleet: A Narrative of Naval Aviation's Early Development, 1910–1916* (N.p.: n.d.), 23, 69–70.

207. Sweetman, *Naval Academy*, 166; cites Thomas Ray, "The First Three," *USNIP* (January, July, October 1971).

208. Miron, personal interview with Norman Owens and Henderson's *Chesapeake*, 213; cites personal correspondence with Norman Owens, July 26, 1995.

209. Sweetman, *Naval Academy*, 193; cites Robert W. McNitt, "Challenge and Change, The Naval Academy 1959–1969," *Shipmate* (April 1972).

210. Henderson, *Chesapeake Sailing*, 252.

CONCLUSION

211. Personal experience with Admiral and Mrs. Frank Thorp, Fall 2008; and personal interview, March 8, 2009. *Plein Air* is owned by the author's husband.

About the Author

Rosemary Freitas Williams is an award-winning journalist with over thirty years' experience covering local, national and international news. She is the proud recipient of numerous journalism awards, including a National Emmy for team coverage of the attacks of September 11, 2001. As executive producer of news for MSNBC for several years, Rosemary supervised news coverage of Washington, D.C., and politics for the twenty-four-hour news channel.

Rosemary is also a professional watercolor artist and a member of the Chesapeake Bay Maritime Museum, the Annapolis Maritime Museum, the Anne Arundel Historical Society, the Maryland Federation of Art, the Maryland Plein Air Painters Association, Art Between the Creeks and the Eastport Business Association. Rosemary lives in Eastport, Annapolis, with her husband, John, a retired U.S. Marine, and two black lab–mix dogs, Samantha and Princess Buttercup.